IMAGES
of America

MOUNTAIN BROOK

Robert Jemison Jr., the visionary who developed Mountain Brook Estates, also helped shape the landscape of residential life in the Southeast as we know it today. Born in 1878 in Tuscaloosa to Robert Sr. and Eugenia Rebecca Sorsby Jemison, he moved to Birmingham in 1884 with his family, graduated from the University of the South (Sewanee) in 1899, and returned to Birmingham, where he married Virginia Earle Walker in 1901. He founded Jemison Real Estate & Insurance Company in 1903 and became a successful real estate developer, with Mountain Brook Estates as his crowning achievement. He was a humble and gentle leader with God-given conviction searching for a "promised land" where people could have more than just a house and a lot; where they could "fulfill their ideals of a home place" and build something for future generations "worthy to be remembered." (Courtesy of Caroline Jemison Kelly.)

ON THE COVER: Leon Edwards is seen here on his fifth birthday with cake, balloons, and party favors galore in the dining room of his parents' home on Southwood Road, where he and his siblings, Bamie, Betsy, and Sterling, celebrated with friends. His father, Sterling Edwards, started the first Chevrolet dealership (Edwards Chevrolet) in Birmingham in 1916, which will celebrate its 100th anniversary in 2016. It is still family owned and operated. (Courtesy of Leon Edwards.)

IMAGES
of America

MOUNTAIN BROOK

Catherine Pittman Smith

ARCADIA
PUBLISHING

Published by Arcadia Publishing
Charleston, South Carolina

Printed in the United States of America

Library of Congress Control Number: 2014938127

For all general information, please contact Arcadia Publishing:
Telephone 843-853-2070
Fax 843-853-0044
E-mail sales@arcadiapublishing.com
For customer service and orders:
Toll-Free 1-888-313-2665

Visit us on the Internet at www.arcadiapublishing.com

*This book is dedicated to my daughter, Sadie, who is a bright
and guiding light in this world. East meets West.*

CONTENTS

ACKNOWLEDGMENTS

Many hands are needed for important tasks, and I am so thankful to the many individuals and families who have shared not just their photographs, but more importantly, their time, stories, and memories with me. I pray that I do them all justice because it is not possible to compile a book of this nature without help and contributions. The majority of this book comes from the oral histories and photographs of many Mountain Brook families. Please forgive me for not including everyone and everything. I tried. Simply put, there's enough material for another edition. Outside of giving birth to my daughter, this book has been my proudest creation—a true labor of love.

In addition to those credited throughout the book, I want to thank, in no particular order, Wally Evans, Mary K. Wilson, Helen Simmons, Sam Johnson, Peggy Montgomery, Barbara Lummis, Laurie Hereford, Billy Krueger (KFC), Gates Shaw, June Emory, Robbie Robertson, Ro Holman, Bee Morris, Richard Randolph III, Margie Gray, Betty O'Neil, Carolyn Davis, Larry Brook, Anne Heppenstall, and Kathleen Watkins for going above and beyond.

The following books were extremely informative: Marilyn Davis Barfield's *A History of Mountain Brook, Alabama & Incidentally of Shades Valley*; Helen Pitman Snell's *Crestline – A Timeless Neighborhood*; Birmingham Historical Society's *The Jemison Magazine*; Marilyn Davis Jackson's *From a Brush Arbor*; Elbert S. Jemison Jr. and Wendell O. Givens's *Robert Jemison Jr. – A Man With a Vision*; and Birmingham Historical Society's *Mountain Brook – A Historic American Landscape*. Articles from the 50th anniversary edition of *Mountain Brook* magazine proved helpful as well.

I want to thank Caroline Jemison Kelly (JFC) for entrusting me with Robert Jemison's treasured personal papers and photographs. I am indebted to Kitty and Gordon Robinson (RFC), Louise and Sharp Gillespy (GFC), Mimi and Bill Tynes (TFC), Ivey Jackson, and Meg McGriff North (MFC) for sharing their generous stories and for opening their homes and scrapbooks. This would not have been possible without the help of Mountain Brook city manager Sam Gaston and his assistant, Doris Kenny, who were incredibly accommodating in sharing materials (CMB). I also want to thank Heather Cooper for her encouragement and organization, Winston Carl for serving as my social chairman, Carolyn Satterfield and Susan Alison for their editing finesse and expertise, Maud Belser for being my rock, Wendy Pollitzer for continual affirmation, and lastly my editor, Liz Gurley, for her patience and guidance throughout this project. I pray that the future generations of Mountain Brook will grow to appreciate our rich history steeped in honor, servant leadership, faith, and tradition.

INTRODUCTION

Long before Mountain Brook became an elite, affluent suburb of Birmingham, the area was the hunting grounds for the Creek, Choctaw, Cherokee, and Chickasaw Indians. The earliest Indians were nomadic Paleo Indians who were here as far back as 10,000 years ago. James Rowan was the first man to purchase property in the area, in 1821, in the southeast part of Jefferson County known as Shades Valley. Daniel Watkins, another early pioneer, first settled in Rosedale and Hollywood and eventually bought a large tract of land that became known as Waddell by the turn of the 20th century. Both of these properties were in what is now Mountain Brook Village, from Park Lane to Canterbury Gardens and Watkins Road and Branch. Other early settlers, such as the Byars, Hickman, and Pullen families, purchased land in what are now the areas of the Birmingham Zoo, the Botanical Gardens, and Crestline Heights.

Another significant settler was Wallace S. McElwain, who relocated his foundry from Mississippi during the Civil War. Cahaba Iron Works (Irondale Furnace), situated on the Furnace Branch of Shades Creek in present-day Cherokee Bend, began manufacturing pig iron for the Confederacy in 1864. After the Civil War and the birth of Birmingham in 1871, settlers, largely from Georgia, Tennessee, and North and South Carolina, migrated to the area and began developing it, including the Bearden, Franke, Goode, and Holcombe families. By the turn of the 20th century, small farms, dairies, and grocery stores existed in the burgeoning area.

In the early 1900s, Robert Jemison Jr. and Birmingham mayor Mel Drennen began planning a community in Blount Springs, where summer homes already existed on a mountainside beside a stream that was already called "Mountain Brook." However, when Mayor Drennen died, so did their dream. Jemison, an established real estate developer, had Corey (Fairfield), Ensley Highlands, Central Park, and Redmont Park in his portfolio. In search of a "promised land," Jemison envisioned a place where people could "fulfill their ideals" and enjoy the "country atmosphere" while living in close proximity to Birmingham. In 1926, Jemison, with William F. Franke, A.B. Tanner, and Charles B. Webb, incorporated Mountain Brook Estates with capital stock fixed at $250,000, and his dream was finally realized.

Jemison envisioned an upscale residential estate community with handsome homes and amenities, providing paved streets, sidewalks, sanitary sewers, and gas lighting. To help him translate this vision into a reality, Jemison hired the best national and local practitioners to design Mountain Brook Estates. Heading the list were nationally renowned landscape architect Warren H. Manning and the South's foremost city planner and landscape architect, William H. Kessler. Manning and his partner Frederick Law Olmsted's portfolio also included New York's Central Park and the Biltmore Estate in Asheville, North Carolina. Many of the facilities and homes were constructed in the English Tudor style, with Italianate, French Norman farmhouse, Georgian, and Federal Revival styles also being popular.

The architects' plans called for estate-sized lots along winding scenic roads, and denser commercial development centering on three contiguous "villages" within walking distance. The well-planned

Mountain Brook community had recreational centers such as a riding academy, golf clubs and courses, business centers, and schools. As Jemison said of his labor of love, "Before a single stone was turned in Mountain Brook, every estate in this thousand-acre development was plotted. Roads and streets were planned for greatest convenience, privacy, and beauty. The unspoiled beauty of Mountain Brook lends itself naturally to gracious living . . . the unusual contour and heavy natural growth in this area has been developed on every estate."

With the stock market crash in 1929, soon followed by the Great Depression and World War II, Jemison's planned community of Mountain Brook was severely affected, with many families losing everything. Through these difficult times, the Mountain Brook community rallied and came together, with residents making sacrifices for the war effort. In the spring of 1942, in the midst of the war, Mountain Brook was incorporated, and the residents elected Charles F. Zukoski as the city's first mayor. Serving until 1955, he established the first council-manager form of government in the state of Alabama. His leadership resulted in effective city planning, zoning boards, and municipal development, with city services that included police and fire protection, sewage disposal, and other needs. When the difficult political and economic events ended, Mountain Brook experienced a resurgence of growth.

Within 15 years, Mountain Brook nearly tripled in size, both in population and geography. With extensive residential and commercial growth, the established zoning board provided restrictions to protect and preserve the natural beauty that Jemison's original plan honored. Still growing in the 1960s, Mountain Brook annexed the Abingdon and Shook Hill neighborhoods in 1961. Hamilton Perkins began developing Cherokee Bend in 1964, and later, Brookwood Forest. There were several attempts for Mountain Brook to merge with the city of Birmingham. However, the citizens opposed annexation in 1964 in order to maintain their own separate school system, which was established in 1959. With the generous contributions of the Elizabeth and Kirkman O'Neal Foundation, the city welcomed the addition of a public library in 1965.

Since the original vision of Robert Jemison in 1926, Mountain Brook has evolved into a mature "small city" with a population just over 20,000. With rolling hills and graciously wooded neighborhoods, Mountain Brook has been called a "forested cathedral" that still reflects the ingenious plan of Jemison, Manning, and Kessler. With four distinct neighborhoods—Crestline, Mountain Brook, Cherokee Bend, and Brookwood Forest—the city is situated on 12 square miles. Listed as one of the wealthiest communities in the United States, Mountain Brook is a unique Southern community. It is a beautiful and hospitable place in which to live, where the citizens are philanthropic, socially sophisticated, and culturally forward-thinking. Jemison's courageous vision, servant leadership, and time-honored principles were key factors when he built Mountain Brook as a secluded suburb of Birmingham. Today it is an independent city with a legacy and roots steeped in honor, faith, and tradition.

Jemison's lifelong creed came from Daniel Webster: "Let us develop the resources of our land, call forth its powers, build up its institutions and promote all its great interests and see whether we, in our day and generation, may not perform something worthy to be remembered." Jemison did just that.

One

THE EARLY YEARS
VISION, DEVELOPMENT, AND WORLD WAR II

Mountain Brook's official logo is the image of the "Old Mill," originally built as a gristmill by John Perryman in 1867 and now a private residence. Jemison rebuilt it in 1927 as an attraction of his new development of Mountain Brook Estates. The tearoom served breakfast, luncheon, and dinner. The rustic atmosphere featured a stone fireplace, hand-wrought lighting fixtures, pegged furniture and doorways, and wide, pine-plank flooring. Located on Mountain Brook Parkway, it is situated on Shades Creek, strewn with mountain laurel, native azalea, and ferns, in the heart of Mountain Brook. (Courtesy of Birmingham Public Library Archives.)

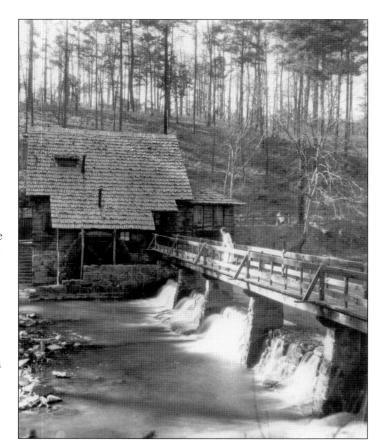

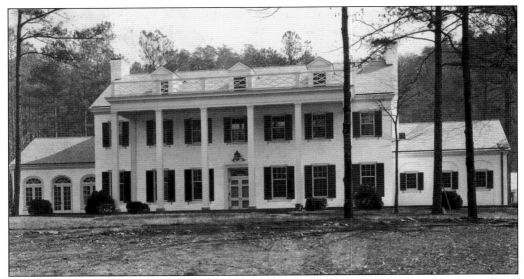

As paving on Mountain Brook Parkway was completed in early 1928, so was the model country home for Mountain Brook Estates, purchased by Herbert Tutwiler. Warren, Knight & Davis Architects designed the Colonial home. Patterned after Mount Vernon, it had all the "appurtenances . . . including stables, paddock, swimming pool, tennis courts, lawns, orchards, formal and informal gardens." After being the setting for the filming of *Stay Hungry*, a novel turned movie written by Birmingham author Charles Gaines, the Tutwiler home later became the decorator's show house in 1977. (Courtesy of Birmingham Public Library Archives.)

Robert Jemison hired Warren H. Manning and William Kessler, renowned regional planners and landscape architects, to design Mountain Brook Estates. It was wooded with pine, hickory, oak, black gum, beech, tulip poplar, sycamore, dogwood, redbud, sourwood, and sweet gum trees. They maintained the natural charm of the residences by merely enhancing and preserving the natural views and landscape. The bridges and entrance gates were designed to blend in with the rustic background. Native sandstone from Shades Mountain was used to construct the rugged arches of the bridges. (Courtesy of Birmingham Public Library Archives.)

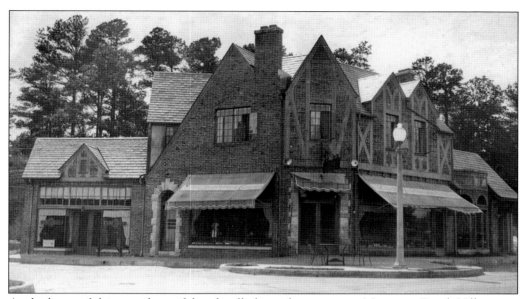

At the heart of this most beautiful and well-planned community, Mountain Brook Village was designed in the English Tudor style "facing on a circle from which five streets radiated." The Jemison Companies established high development standards for the shopping centers. Construction began with nine units in two groups on opposite sides of the Village Circle. Gilchrist Drugs (originally Mountain Brook Drugs) and Martha Washington Candy Shop were among the first tenants. (Courtesy of Birmingham Public Library Archives.)

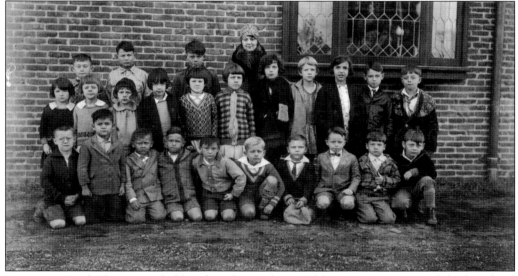

Mountain Brook Elementary held its first classes above Gilchrist Drugs in 1928 while the school was being built, and then moved to its permanent location in 1929. Pictured here from left to right are (first row) Bill Harbert, two unidentified, John McReynolds, George Ward, Bill Schuler, unidentified, George Dobbins, Mailon Everett, and Charley Jones; (second row) Jeanette Murphy, Frances Franke, Gladys Hensley, Amelia Cocke, Frances McClusky, Reba Hensley, two unidentified, Elizabeth Cocke, Wells Stanley, and Fred Jackson III; (third row) three unidentified and the teacher, Mrs. Mitchell. Harrison Limited occupies this building today. (Courtesy of Robbie Robertson.)

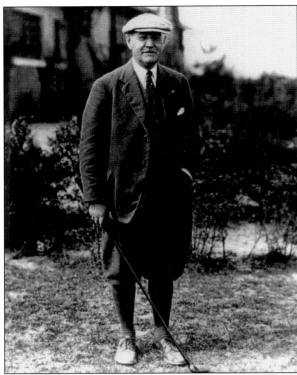

Jemison's vision for the development of Mountain Brook included outdoor recreation. Wanting the golf courses to be among the finest in the country, he hired Scotland's Donald Ross (pictured), who was recognized as the best golf course designer at the time, having designed over 600 courses. Ross described Mountain Brook Club's course in a letter to Jemison: "The course is one of unusual beauty and the holes have character and individuality . . . the whole setting is one of great attraction." (Courtesy of Anne Heppenstall.)

Built on an elevated knoll, Mountain Brook Club opened in April 1930. The American Colonial clubhouse touted a "superb panoramic view of distant mountain ranges and rolling, green fairways." Nationally renowned architect Aymar Embury II of New York and the Birmingham firm of Miller & Martin designed the charming, traditional club, "personifying the spirit and traditions of the old south in architecture, appointments, environs and atmosphere." (Courtesy of Birmingham Public Library Archives.)

In 1934, on most any afternoon at 5:00 p.m., one could find Will Dunn and Herbert Tutwiler playing tennis and serving hot and fast across the net on the courts at Mountain Brook Club. Both gentlemen were largely responsible for popularizing the sport locally. In July 1929, George Gordon Crawford was elected president and Temple Tutwiler vice president, with Thomas W. Bowron as treasurer. (Courtesy of Mary French.)

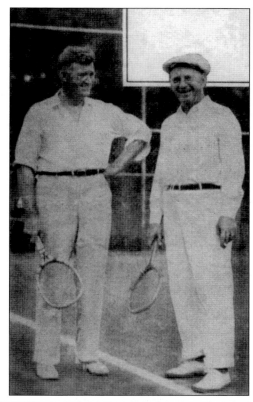

The 1934 Mountain Brook Club football team included, from left to right (first row) Buddy DeBardeleben, Gene Moor, Fred Dow, John Farley, Taylor Marshall, Temple Tutwiler, Tony Marzoni, Charley DeBardeleben, and Doug Shook; (second row) Bill Edmonds, Kelly Seibels, Prince "Boots" DeBardeleben, Keehn Berry, Jelks Cabaniss, Dan Pratt, Crampton Harris, David White; (third row) Bobby Shook, Jim Strange, Porter Stiles, Charley Jones, and coach and manager Sax Crawford. (Courtesy of Temple Tutwiler.)

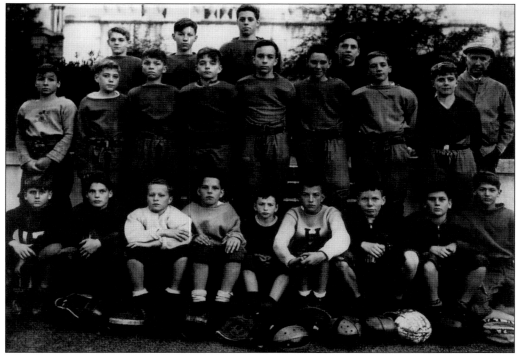

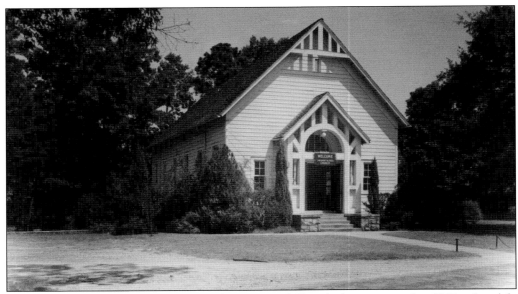

Pictured above is the Union Hill Methodist Episcopal Church, first organized in 1867 as Irondale Methodist near the Irondale furnace. It moved to Union Hill in 1873 on property donated by Pleasant Hickman Watkins on present-day Hollywood Boulevard. The adjacent Union Hill cemetery is the burial ground of many pioneers and early settlers of Shades Valley. Union Hill School opened in the church soon after its completion. It was the first school in the area and later merged with Shades Cahaba High School in 1920. In 1928 when Robert Jemison began developing Mountain Brook, the church was extensively renovated and renamed Canterbury Methodist Episcopal Church after Canterbury Cathedral in England. The name tied in with the English Tudor style of homes in Mountain Brook. The sanctuary, pictured below, was beautiful in its simplicity. The church was torn down when Highway 280 was improved. (Both courtesy of Canterbury United Methodist Church.)

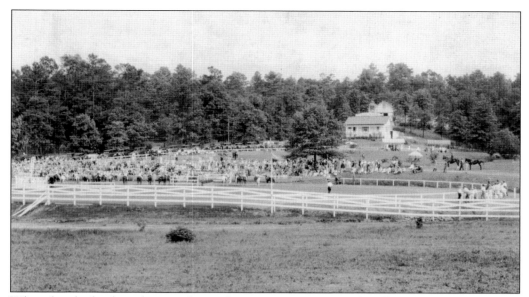

When first built, the riding academy adjoining Mountain Brook Village, located on Cahaba Road, housed over 60 horse stalls, a blacksmith shop, and a staff veterinarian. In the spring of 1929, the first amateur horse show was held there. Mrs. Charles Clingman's unit of the Church of the Advent Women's Auxiliary, which included many Mountain Brook ladies, sponsored the major social event. (Courtesy of CMB.)

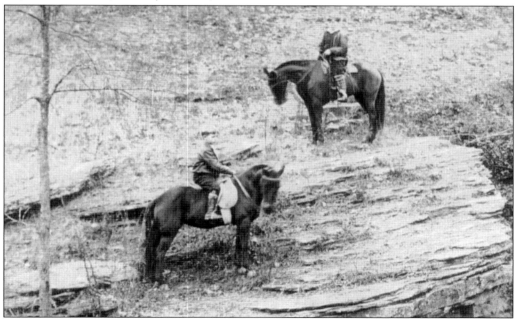

Taking advantage of the nearby Mountain Brook riding academy and the 40 miles of bridle paths, David Thurlow and Eugene Yates ride their ponies along Shades Creek on trails near the Old Mill. There were many miles of trails winding along streams and through wooded valleys that families enjoyed on Sunday afternoon outings. Some of the riding trails are still visible on Overbrook and Cherokee Roads. (Courtesy of Anne Heppenstall.)

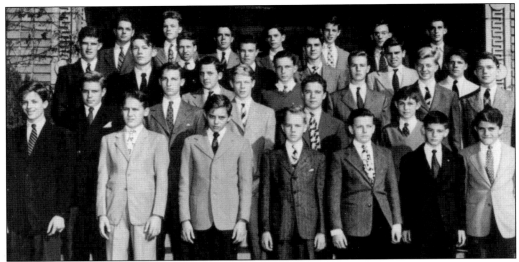

The Sigma Club became the Alpha Sigma Delta Fraternity on October 28, 1922, providing young men with companionship and brotherhood. The fraternity met at Felton Wimberly's Forest Park home. Fraternities and sororities played an important role in the social life of Mountain Brook and Birmingham teenagers, who attended different high schools, including Shades Valley, Ramsay, and Phillips. The Sigmas published an annual joke booklet called the *Sigma Bee*. (Courtesy of GFC.)

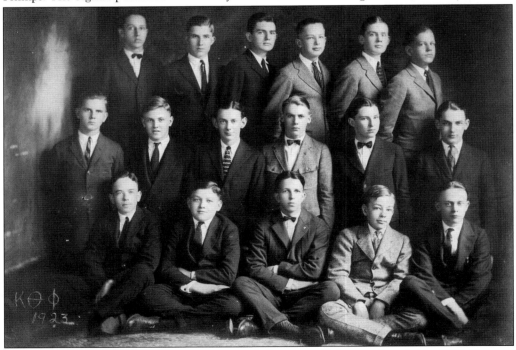

The Kappa Theta Phi fraternity, more commonly known as Kobe, was founded in 1923. Pictured from left to right are (first row) John Kelly Murphy, Hugh Morrow, Robert Baugh, Arnold Edmunds, and John Lake Parker; (second row) Walter Phillips, Bodie Fiddler, Tom McDavid, Duncan McArthur, Angus Taylor, and Covington Riley; (third row) Fred Stack, Guy Travis, Bryant Sells, Fletcher King, Bryan Chancey, and James Arthur Smith. (Courtesy of Ann King.)

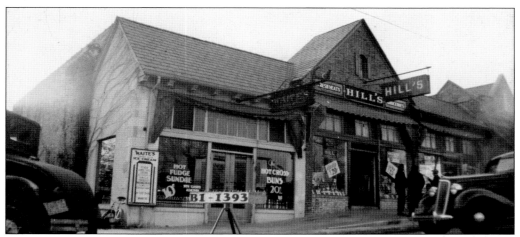

English Village lies in the middle of what used to be an old wagon trail known as the Old-Florida Short Route. Carolyn Smith, Alabama's first female architect, was the first to build there in 1918. The second business district built by Jemison & Company, it was home to Waite's, Hill's, and Park Lane Grocery. The charming village is smaller than the other two and offers an old-world atmosphere with great art galleries and eateries. (Courtesy of Birmingham Public Library Archives.)

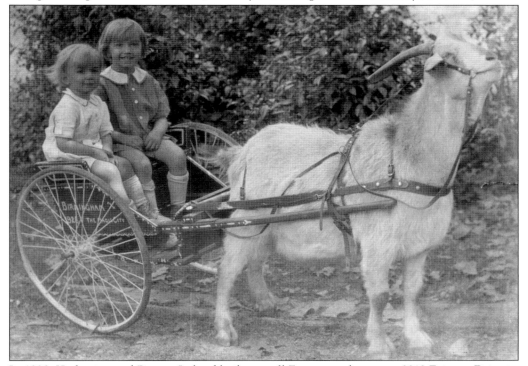

In 1928, Katharine and Barney Ireland built a small European chateau at 2919 Fairway Drive in Mountain Brook, outside English Village. Pictured here are their sons, Glenn and Bill. Barney's father, Charles Byron Ireland, was an early pioneer in Birmingham originally from Ohio. He started Birmingham Slag and later formed Vulcan Materials, the nation's largest producer of construction aggregates, primarily crushed stone, sand, and gravel. Edna H. Bushnell lives in the house today. (Courtesy of Glenn Ireland.)

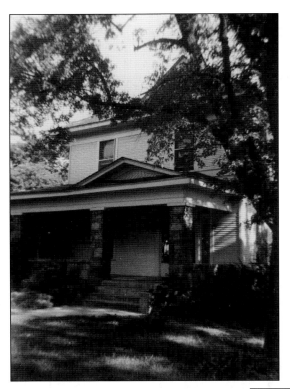

Originally built in 1902 as the Robert P. McDavid summer home, this Euclid Avenue house did not have running water or electricity. In the 1940s, Earl Stringfellow owned it and the surrounding property, including a barn and a small lake. Judge E. David Haigler purchased it in 1950 and sold it to the Mogge family in 1965 for $18,000. (Courtesy of Kathleen Watkins.)

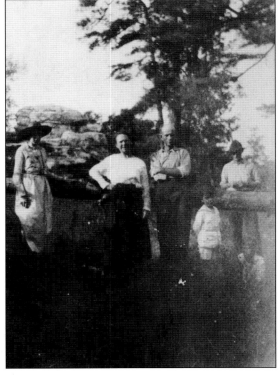

John Benjamin McClusky (right) and his wife, Clementine Yates (left), are pictured here in the 1920s with family members at the Indian "rock house," which families often frequented for picnics, Sunday outings, and gatherings. Children would explore the caves in the rocks, which had, centuries earlier, provided shelter for the Indians. This area was later developed into Rock House Circle, which is now Rockledge Road, across from Birmingham Country Club. (Courtesy of Robbie Robertson.)

Before Crestline and Mountain Brook Elementary Schools were built, children attended Avondale, Lakeview, and South Highland Schools in the Birmingham Public School System. The motto was, "The Home and the School should work together for the Good of the Child." The report cards gave credit for Sunday school attendance and provided the age, weight, and height of the pupils. (Courtesy of Sam Johnson.)

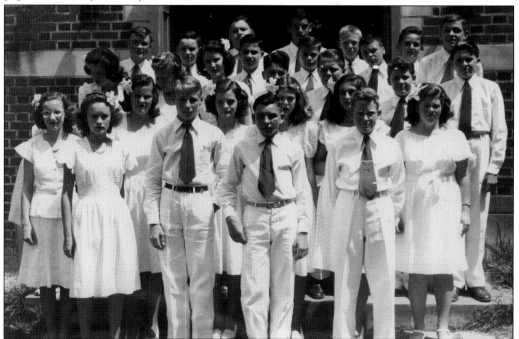

Before Jemison began developing Mountain Brook in 1926, planned development had been underway in Crestline since the early 1900s. In 1907, the Crestline land company laid out roads such as Jackson, Dexter, Euclid, and Mountain Avenues, and Oak, Church, Main, and Cherry Streets. James Eastis donated the property for Crestline Heights Grammar School on Church Street. Pictured in front of the original building is the 1946 eighth grade graduating class. (Courtesy of Ann Hicks.)

Around 1918, Richard R. Randolph Sr. obtained a "house in the country" in Shades Valley, where his family could get away from the bustle of rapidly expanding Birmingham. Known to the family as "the Cottage," it was located at 715 Fairway Drive. Randolph and Harrison Matthews purchased approximately 60 acres of land adjacent to that property and south of the new home of Birmingham Country Club, and developed Country Club Gardens. (Courtesy of Richard Randolph III.)

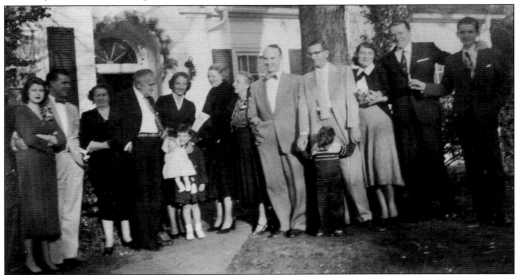

One of the first homes, designed by Warren, Knight & Davis Architects, was at 59 Matthews Road, built by Judge Stephen B. and Marietta Randolph Coleman. Pictured from left to right at Christmas in 1953 are Florence Murphree, Harry Wheelock, Helen Rosa Randolph Murphree, Richard R. Randolph Sr., Nancy and Jean Randolph, Lillian Fant Randolph, Sue Randolph, Jack Monaghan, Carter and Bobby Randolph, Lee Randolph, Richard R. Randolph Jr., and Richard R. Randolph III. The original address was 59 Country Club Gardens. Today, the house has been completely rebuilt by Miller Gorrie. (Courtesy of Richard Randolph III.)

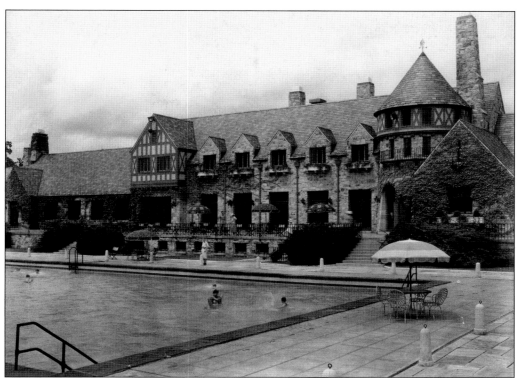

The Country Club of Birmingham was founded in 1898 by 77 prominent Birmingham businessmen and was first located near the trolley line in North Birmingham as a driving club for horse-drawn buggies. The club relocated to Highland Avenue, where it welcomed members and noted guests, including Pres. Theodore Roosevelt. Henry Key Milner and Robert Henry Baugh were the first two presidents. It permanently relocated to its present location, on farmland in Shades Valley, in 1926. (Courtesy of Birmingham Public Archives.)

The Birmingham Country Club golf course, designed by Donald Ross, opened in 1926 along with the swimming pool. The following year, Warren, Knight & Davis completed an English Tudor–style clubhouse situated between the two golf courses. In 1998, the club celebrated with centennial gala events and acknowledged its sportsmen, women, and children by displaying a permanent trophy room representing golf, tennis, swimming, and diving accomplishments. Pictured are Melanie Drake (left) and a friend on the pool deck. (Courtesy of Melanie Parker.)

The Lula and Frank Drake family was one of the first to buy in the newly developed Country Club Gardens at 43 Greenway Road, where they raised their children for many years. Their daughter, Melanie, is pictured here with her nanny, Maggie Mango, who, like many African American nannies, was instrumental in raising the children. There was a communal mailbox at the entrance to Country Club Gardens where mail was received; bluebirds often nested there. (Courtesy of Melanie Parker.)

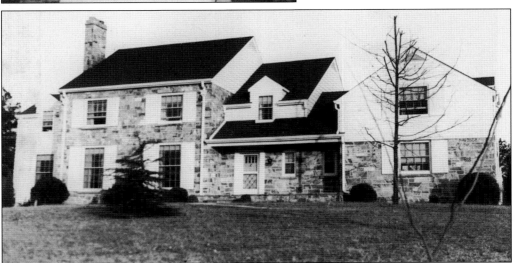

Helen Rosa Randolph and her husband, Judge Thomas A. Murphree, built a lovely Garrison Colonial home at 73 Country Club Boulevard in 1938. The original cost was $16,364.70. Unfortunately, the stock market collapse and the Depression caused many developers to lose their properties and investments, but at least their vision and creations of beauty still live on today. (Courtesy of Richard Randolph III.)

Built in the early 1920s, Raymond and Marguerite Jones's home was the first one built on Pine Ridge Road, then a dirt road. Situated on three lots, it was a home where friends, such as Ellen and Petie Cross, who lived next door, played with their daughters Marguerite "Wita" and Alice "Acky." Cows from the farm behind would wander up to cool on the porch's stone floor before it was screened in. Pictured below are Marguerite Nabers Jones and Acky (left) and Wita (right) in their driveway in the early 1930s. Acky later married Lee "Pete" McGriff, and Wita married John Harbert. This home held many gatherings and memories for their family, including grandchildren Lee, Meg, Addie, and Jane McGriff and Jay, Raymond, and Marguerite Harbert. (Above, courtesy of Margie Gray; below, courtesy of MFC.)

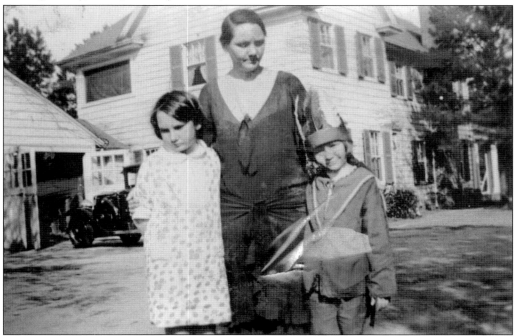

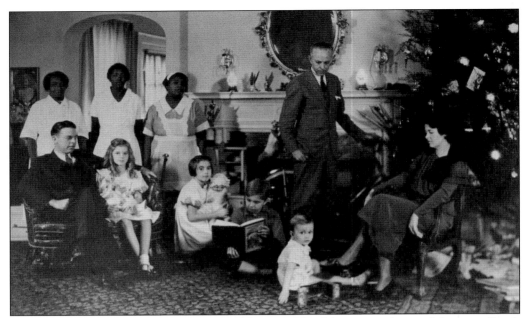

Many early Mountain Brook families moved from Highland Avenue to the new Mountain Brook Estates. Bet and Sterling Edwards bought on Southwood Road in 1930. Seen here celebrating Christmas are, from left to right, (first row) Leon Wyman; the Edwards children, Bamie, Betsy, Sterling, and Leon; Sterling Edwards; and his wife, Elizabeth "Bet" Alabama Wyman; (second row) Sally, Emma, and Johnnie, the children's nannies. (Courtesy of Leon Edwards.)

John Parker Evans married Virginia Bedell Burt of Opelika, and they built their home on Watkins Road in 1930 on two lots near Watkins Branch in Waddell. Because of her enormous love of horticulture, Mrs. Evans served as president of the Little Garden Club in 1950 and 1960. The club was founded in 1928 and is a Garden Club of America affiliate. She was instrumental in starting the Birmingham Botanical Gardens. Today, their grandchildren and great-grandchildren live in the family home, as well as an additional home built in 2008. (Courtesy of Wally Evans.)

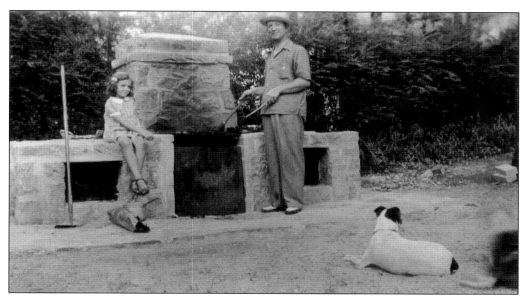

On the Fourth of July, A.E. "Buddy" Quinn (center), pictured with his daughter, Mary K., and their fox terrier, Honey, loved to cook "camp stew" and grill on the barbecue pit he built on Hastings Road. He and his wife, Katharine, loved to entertain in the backyard with neighborhood friends, such as the Randalls, Ards, Coxes, McWhorters, and Mudds. The Quinns moved there in 1936 from Hollywood. Mary K. later married Tommy Wilson. (Courtesy of Mary K. Wilson.)

Dr. Frank Cunningham Wilson and his bride, Emily Bland Symington of Baltimore, married in 1924 and had five children. In the mid-1930s, they bought a large, Federal-style home at 2632 Mountain Brook Parkway with a barn in the backyard. The four boys, pulling a typical prank, took their horse upstairs while their parents were out. From left to right in 1945 are (seated) Frank Jr. and Emily "Mimi;" (standing) Tommy, Bland, and Billy "Watlo." (Courtesy of TFC.)

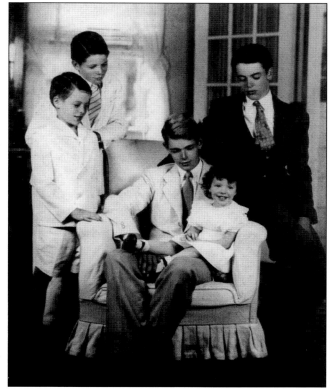

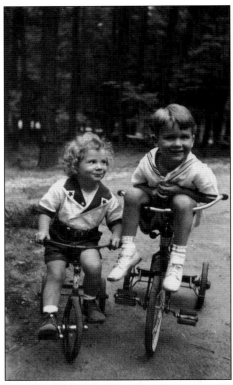

In early Mountain Brook in the 1930s and 1940s, people left their homes unlocked and their windows open. Nobody had televisions, and the children rode their bikes, played in the neighborhood streets, and swam in Shades Creek on Mountain Brook Parkway. Walter "Bruddy" and Parker Evans are pictured here riding tricycles in their driveway on Watkins Road. (Courtesy of Wally Evans.)

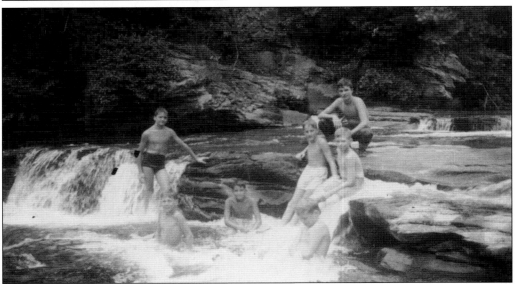

The boys who lived off of Mountain Brook Parkway on Southwood, Guilford, and Hastings Roads, such as Leon and Sterling Edwards, Bobby Parker, Michael Pizitz, Francis Crockard, George Elliott, and Richard Cox, frequented Shades Creek to go swimming, fishing, and frog gigging. Sterling Edwards later became an internationally known cardiovascular surgeon and is credited with developing the first synthetic arterial graft used in a human. He also introduced many surgical techniques related to revascularization of the heart. (Courtesy of Leon Edwards.)

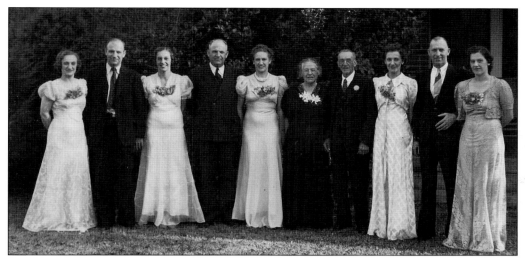

Paul Emil Franke, a German immigrant, married Dulcenia Watkins in 1888. They built on property in Waddell on Montevallo Road, deeded by her grandfather Daniel Watkins, an early settler of Jefferson County. Their son William incorporated Mountain Brook Estates with Robert Jemison. The Frankes are seen here celebrating their 50th wedding anniversary with their children. From left to right are Bertha, Albert, Clara, William, Edna, Dulcenia, Paul, Olga, Hermann, and Virginia. (Courtesy of Blair Cox.)

Landon "Tim" and Mary Timberlake purchased their home on Guilford Road from William E. Matthews III in 1947, after World War II. Builders laid roads throughout Mountain Brook that accentuated the natural contours of the land, with every estate designed to have a sylvan setting, as nature devised it. The Timberlake home was a typical example of this visionary and forward-thinking planning. (Courtesy of Betty Knight.)

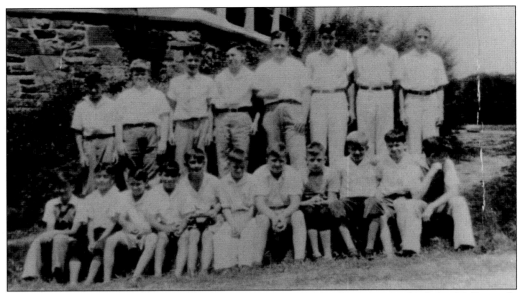

Bessie Wilhelm was the first principal of Mountain Brook Elementary, which had 143 pupils enrolled in 1929, its first year. The 1935 Mountain Brook Elementary male graduates were, from left to right, (first row) Buddy Geisking, Doak Mudd, George Rush, Ralph Rice, Nimrod Long, John M. Harbert III, Robert McCalley, Harrison "Hack" Lloyd, Bill Schuler, Emmet O'Neal, and W.C. "Bill" Lloyd II; (second row) Mailon Everett, ? Cochrane, Joe Shaw, Arthur Major, Neville Weir, Thomas Kilpatrick Lee, Kenneth Dean, and Clinton Sheppard. (Courtesy of Margie Gray.)

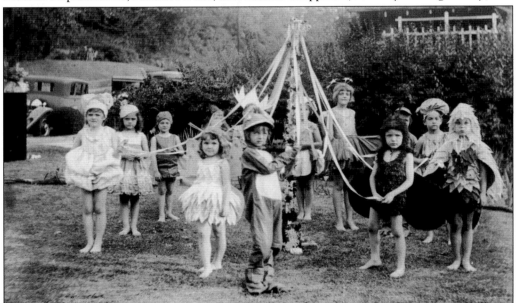

Jack, Franklin, and Bobby Parker grew up on Southwood Road. The children of Margaret and John, they lived next door to the Elliott family. Pictured here are friends dressed up to celebrate Franklin's birthday and the arrival of spring with a Maypole dance. Their father, John M.G. Parker, was an Army captain in World War I. He was a company commander who trained and prepared troops to go overseas. (Courtesy of Bobby Parker.)

Pictured from left to right are Katharine and Barney Ireland's children, Bill, Glenn, and Kathy, at their Fairway Drive estate. Kathy, having special needs, inspired her brother Glenn to later establish Glenwood, a facility that provides hope, housing, counseling, and services to families with children diagnosed with autism and behavioral health issues. (Courtesy of Glenn Ireland.)

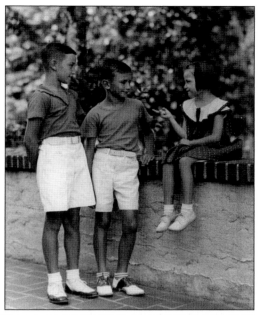

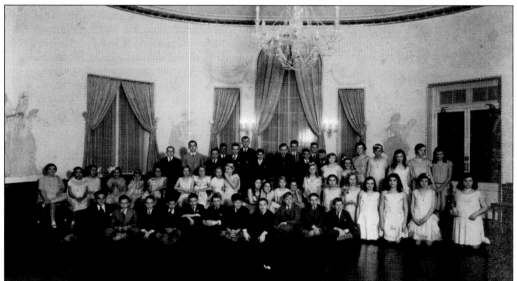

Helen Benedict's 11th birthday party was held at Mountain Brook Club. Seen here from left to right are, (first row) Fletcher Comer, Weatherly Cabaniss, Edwin Mason, George Cabaniss, Bob Mason, Coleman Morton, Freddie Ferguson, Al Woodward, Billy Dunn, Jimmy Meadows, and Dixon Brooke; (second row) Mary Frances McElroy, Jean Steiner, Helen Garber, Caroline Miller, Irene Woodruff, Ginger Ireland, Ellen Cross, Alice Jones, Mary Alice Brown, Mildred Noland, Frances Baldwin, Katherine Leary, Margaret Anderson, Margaret Chenoweth, Jane Hill, Lucie Monette, Helen Benedict, Jane Thach, Betty Clabaugh, Tish Seibels, and Julia Fletcher; (third row) John Sharpe Roberts, Charlie Wilcox, David Thurlow, Bill Ireland, William Hazzard, Fernwood Mitchell, Shelly Bowron, Milner Benedict, Frank Anderson, Joe Leland, Frederick Anderson, Billy McGowen, Bertha Munger, Becky Thurlow, Mary Tutwiler, Virginia Anderson, Jane Randolph, Katherine Crawford, and Innes Comer. (Courtesy of MFC.)

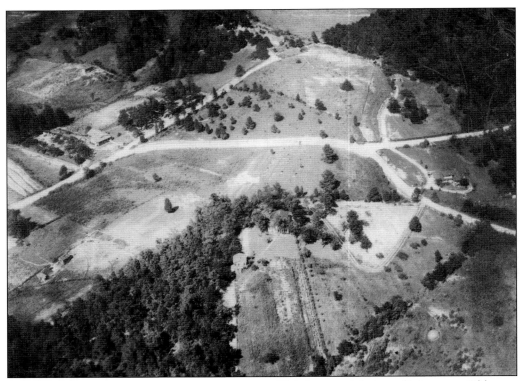

This is an aerial view of Montrose, Old Leeds, and Pine Ridge Roads in 1926. This area was largely dairy farms before development began in the mid-1920s. Earlier, in 1910, Cecil and Alma Logan purchased and added onto a farmhouse on Montrose Road, where they raised their children, Mary Sue "Suzy" and Marshall. They also purchased property across the street, which they sold during the Depression. It was then developed as Mountain Park Circle. The farmhouse remains today, and their property was later developed into Montrose Circle. (Courtesy of Sam Johnson.)

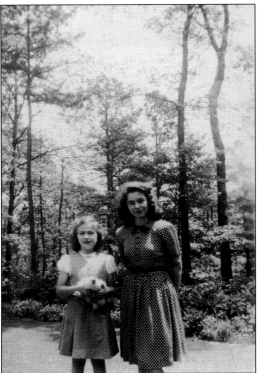

During World War II, it was common for Mountain Brook residents to plant and maintain victory gardens, as well as raise chickens, goats, and cows. Everyone came together to be a community. Kitty and Mallie Moughon are pictured here in 1942 in their backyard at 3155 Pine Ridge Road, across from the Raymond Joneses. Other neighbors included the Allen Rushtons, the Moulton Smiths, and the Bill MacQueens. (Courtesy of RFC.)

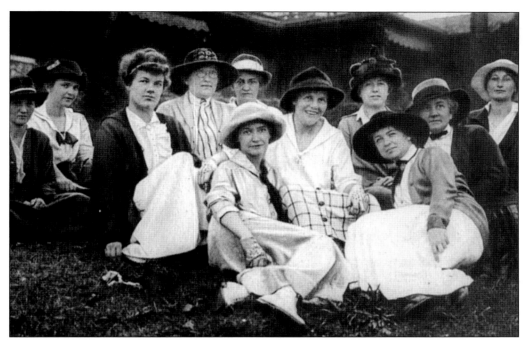

Early in Mountain Brook's history, ladies had a passion for gardening, horticulture, and flower arranging, which continues today. Founded in 1927, Red Mountain Garden Club is a member of the Garden Club of America. The club's purpose is to restore, improve, and protect the quality of the environment through educational programs and action in the fields of conservation and civic improvement. Pictured are early club members. (Courtesy of Hallie Rawls.)

Suzy and Abner C. Johnson built a house on the lot next door to her parents, the Logans, on Montrose Road after he returned from World War II. Pictured in 1945 are their boys, Sam and Andy, and friends at a birthday party where they took a pony-drawn buggy ride in the pasture behind their grandparents' home. As a hobby, the Logans planted gladiolas, dahlias, and tuberoses that they sold to local florists. (Courtesy of Sam Johnson.)

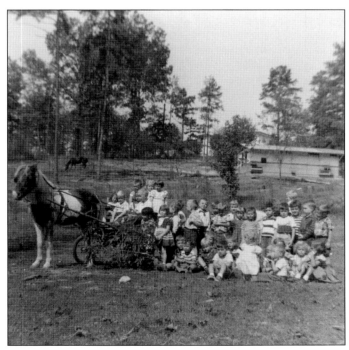

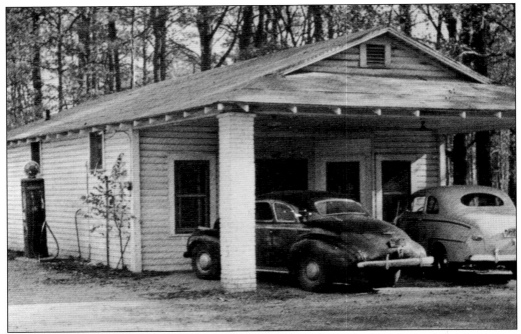

Pictured is Mountain Brook's first city hall, originally purchased by Ida Mae and Ben Levio as a grocery for $1,500. Needing a city hall, Robert Jemison approached the Levios, who sold it for the same amount they purchased it for. Charles F. Zukoski saw a need for police and fire protection in the burgeoning area; in 1940, he and others formed a volunteer organization of police, fire, and sewer service. (Courtesy of CMB.)

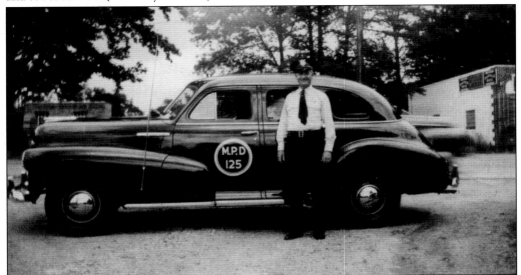

Wanting a more effective means to provide services, an election was called, and the city of Mountain Brook was incorporated in 1942. Charles F. Zukoski was its first mayor. Pictured is patrolman Warren Chandler with the city's first police car in 1943. Chandler and Chief Raymond Tibbett patrolled the streets. They often frequented Crestline's family restaurant, Davis's, for hamburgers and oysters on the half shell. (Courtesy of CMB.)

In 1940, when Dr. Henry Ariail opened his pharmacy and soda fountain in Crestline Heights, there wasn't much retail in the area. The drugstore became a local hangout for the sorority and fraternity teenagers, where twin-burgers and fries were just 49¢. Across the street was Club Village Market, owned by Ida Mae and Ben Levio, where residents called in grocery orders and Billy Moughon delivered them. Leigh Gray purchased the drugstore from Dr. Ariail in 1974. Since 1990, the former pharmacy has been home to La Paz, a favorite family Mexican restaurant. (Courtesy of Wes Pullen.)

Crestline Heights began experiencing major residential and retail growth after World War II, when building materials became more available. Subdivisions such as Glencoe and others were developed, offering attractive homes with a wide range of prices suitable for returning servicemen and young families wanting to move to the area. The A&P grocery store was built on Church Street, in the heart of Crestline Village, in the late 1940s. (Courtesy of CMB.)

Colonial Hills was developed both before and after World War II. John Privett was one of the developers and builders of the homes in this picturesque neighborhood. Pictured here is a newly listed home for sale. During the war there was very little, if any, construction due to the fact that all building materials were needed for the war effort. (Courtesy of Ivey Jackson.)

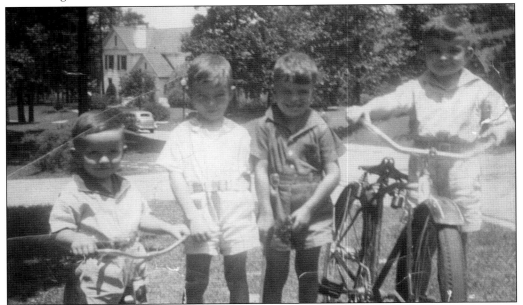

Pictured from left to right are first cousins Donald and Erskine Carmichael, Joe Donald, and John Carmichael. The boys rode bikes and played in the street with Joe's siblings, Tommy and Diane. Joe's parents, Dr. Joe and Kathryn Donald, lived on Surrey Road before he left to serve overseas during World War II. They then moved to Redmont Gardens, which the Jemison Companies developed from 1938 to 1945. (Courtesy of Forsyth Donald.)

Born in 1917, Belton Y. Cooper served as a lieutenant in the 3rd Armored Division in World War II. As a young ordnance lieutenant, Belton's job was to travel with the combat units and assist in coordinating recovery, repair, and evacuation of the battle-damaged tanks. He landed in Normandy, France, on July 4, 1944, just 28 days after D-Day, and later fought in France and Germany, including service in the Battle of the Bulge. He later became a second lieutenant and retired as a captain. Belton was an avid storyteller. At the age of 80, he fulfilled one of his lifelong dreams by publishing his first book, *Death Traps: the Survival of an American Armored Division in World War II*. He died in 2007, just shy of his 90th birthday. (Courtesy of Rebecca Cooper.)

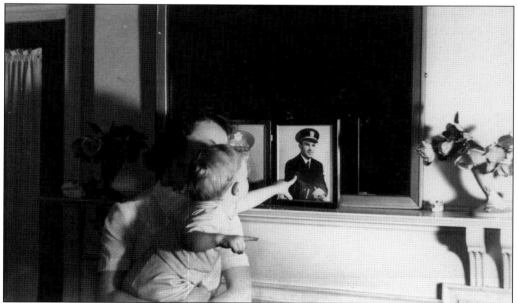

While Abner Johnson was serving in the US Naval Reserve in World War II, his wife and sons lived with her parents, the Logans, on Montrose Road. Johnson was employed by the Federal Housing Administration (FHA) from 1940 to 1953 and was appointed as the Alabama FHA director in 1948 after his return from the war. Johnson's wife, Suzy, is pictured here with her son Andy looking at his father's portrait while he was overseas. (Courtesy of Sam Johnson.)

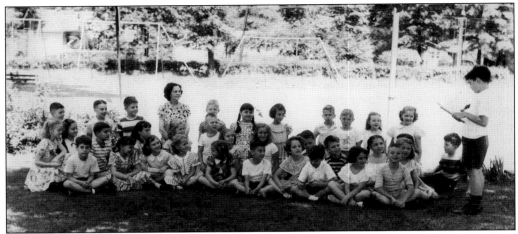

Pictured is a class at Crestline Elementary on the playground in 1947. The city bought up small houses on Elm and Vine Streets and moved them to help create a playground. In 1951, the Mountain Brook City Council spent $5,500 to update it. They added new equipment and a better field for football, softball, and baseball, with the YMCA helping conduct the new recreation program for the youngsters. (Courtesy of Peggy Ragland.)

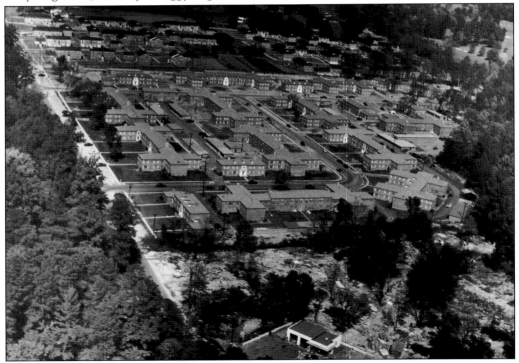

Located on farm property previously owned by the McClusky family and sold to Jemison Properties during the Depression, Park Lane Apartments were developed by A.A. "Rele" Evans in 1948. Built in the Georgian style but with Art Deco details, Park Lane was called home to "the newly wed and the nearly dead." There was a waiting list in order to live there. The apartments were torn down in 2013 to be replaced by Lane Parke Community, including apartments, a hotel, and retail businesses. (Courtesy of CMB.)

Play dates in Crestline were common among neighborhood children, as they are today. Pictured here in 1945 are, from left to right, Hunt and Brooks Emory and Suzanne Hamilton on the corner of Cherry Street and Euclid Avenue. Suzanne's father, David Hamilton, served as the second mayor of Mountain Brook and was instrumental in forming Mountain Brook's own school system. (Courtesy of June Emory.)

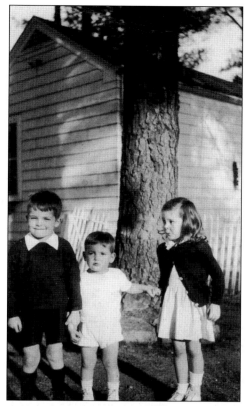

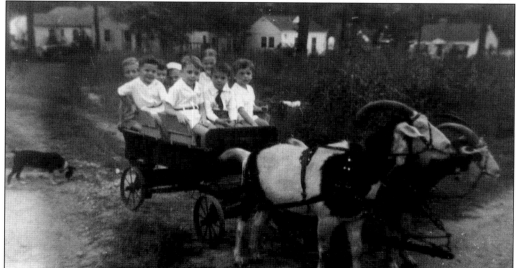

Ed, the "Billy Goat Man," came from Southside to give children free rides in his cart. He kept the goats in the field where BBVA Compass Bank is now. Pictured are neighborhood children celebrating Brooks Emory's birthday on Dexter Avenue, still a dirt road in 1945. Horton and June Emory began building their home on Dexter Avenue in 1940 while they lived with his parents on Mountain Park Circle. (Courtesy of June Emory.)

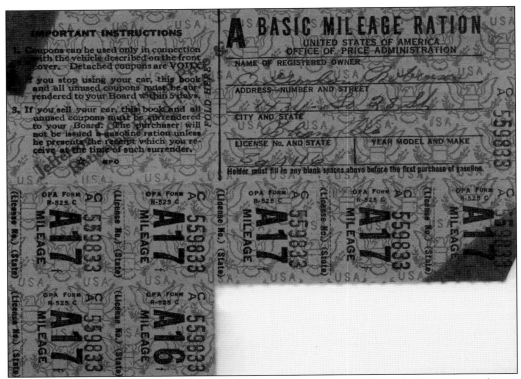

During World War II, everything was rationed, including sugar, gasoline, whiskey, tires, and even shoes (two pairs). Because gasoline was rationed to four gallons a week, people walked, rode bikes, and hitchhiked everywhere. Often on Sundays, families would go down to the train station and take soldiers traveling through town out to lunch. (Courtesy of RFC.)

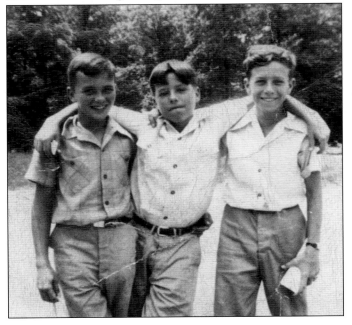

To help raise money for the war effort, parents and students alike bought war savings bond stamps for 10¢ or 25¢. Leon Edwards and Gordon Robinson were elected to take orders from fellow students at Mountain Brook Elementary. They rode their bikes to the Edgewood post office to place the stamp orders. Often upon their return, they climbed nearby trees to avoid returning to class. Pictured here from left to right are Edwards, Robinson, and Sam Whitten. (Courtesy of RFC.)

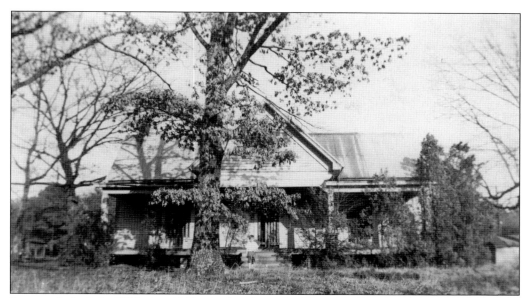

Reportedly built in 1890, the old Herrin farmhouse had become dilapidated and abandoned and was purchased by the City of Mountain Brook in 1947. The site would eventually become home to the Emmet O'Neal Library, but the house was first remodeled to be the first home of St. Luke's Episcopal Church, which leased the Herrin house from the city for $25 per month. (Courtesy of St. Luke's Episcopal Church.)

St. Luke's Episcopal Church opened its doors on Easter Sunday, April 17, 1949, in its first location, the remodeled "little brown church." The first vestry included J.W. Hamilton Jr., John Corey, Frank Davies, Carl Hulsey, P.W. Smith, George Keen, Will Cothran, Jack Wilson, Wade Morton, Ray Pollitt, William Hood, and Dr. Hunter Brown. Rev. George Anderson was the first rector. He was replaced by Rev. Lee Graham in July 1951. (Courtesy of St. Luke's Episcopal Church.)

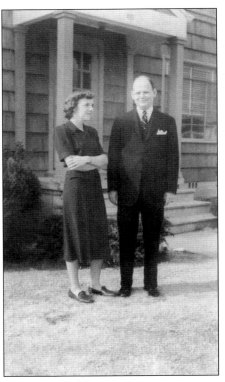

Foxhall Apartments in Crestline were developed by Lou Jeffers, and, like Park Lane Apartments in Mountain Brook Village, they were home to many newlyweds as well as returning servicemen and women from World War II. Pictured are Rebecca and Belton Cooper standing outside their first home in 1949. They had three sons, Lloyd, Spencer, and Belton, and later moved to Salisbury Road. (Courtesy of Rebecca Cooper.)

Mountain Brook's first mayor, Charles Zukoski, established both the police and fire departments in 1942 after the city's incorporation. Pictured in 1943, city manager Charles Webb and city clerk Dorothy Hoyt pose with the fire department in front of the original firehouse. In 1950, more permanent facilities were built to accommodate and respond to the growing Mountain Brook population. (Courtesy of CMB.)

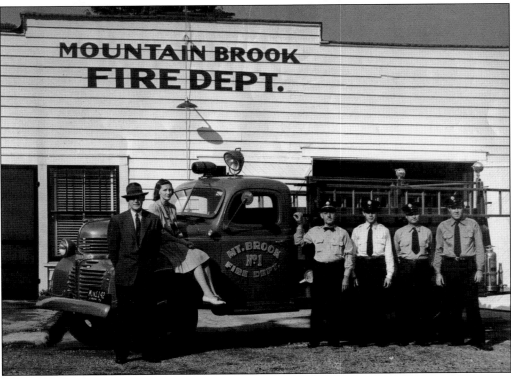

In 1948, Robert Jemison and his wife, Virginia, moved back to his "labor of love" in the valley after living at their 300-acre Spring Lake Farm near Springville for 18 years. A.E. Wynne formerly owned the Balmoral Road home. Virginia Jemison is pictured standing in the beautifully landscaped side yard. (Courtesy of JFC.)

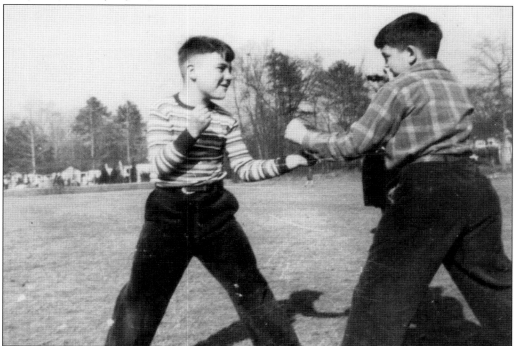

The Mountain Brook Elementary School field was always full of activity during the week at school, as well as on the weekends. Billy Reed (left) and a friend are pictured here duking it out. Dodgeball and red rover were some of the favorite games played on the school's front lawn and football field. Robert Jemison donated 11 acres for the construction of the school. (Courtesy of Wally Evans.)

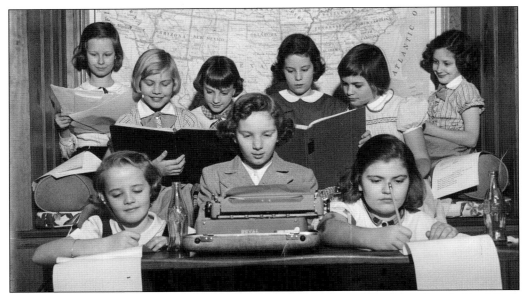

The fifth-grade newspaper team at Mountain Brook Elementary School was founded by Mitzie Hodo (center), editor and publisher. Her trusty reporters were, from left to right, (first row) Sister Cabaniss and Grace Carmichael; (second row) Sally Marbury, Betty Timberlake, Marian Weldon, Polly Fulkerson, Robbie Cox, and Winston Martin. They met every Friday night at Hodo's house and wrote their newspaper, *The Village Star*, and then turned it over to her father's secretary for editing and printing. (Courtesy of Betty Knight.)

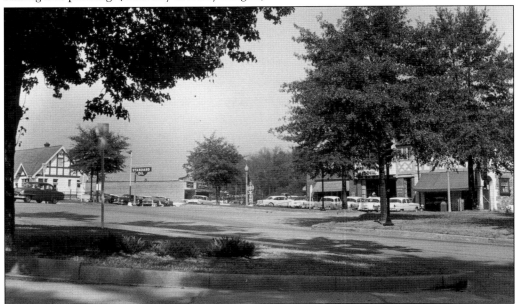

Mountain Brook residents found every convenience they needed in the villages that Robert Jemison envisioned and Warren H. Manning planned. The building at right, where Gilchrist Drugs (originally Mountain Brook Drugs) is located, was the first to be built in the circle, in 1927. Gilchrist Drugs was, and still is, the center of activity for children, who walk from school to get a milk shake or a famous limeade. (Courtesy of CMB.)

Two

GROWTH AND EXPANSION
1950S AND FORWARD

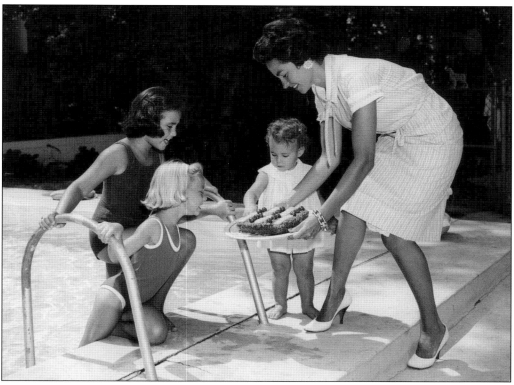

After World War II, the American economy was booming again and people were hopeful about the future. In the early 1950s, many ventured out of the Mountain Brook Village neighborhoods and moved farther out to the outskirts of suburbia. Glenn and Mallie Ireland moved their family to Abingdon in 1958. Mallie is pictured here with her daughters, from left to right, Kacy (6), Mallie (4), and Nonie (2). This photograph was taken for a promotional advertisement for Lily White Flour. The company donated $100 toward the Irelands' favorite charity, the Mercy Home (now Gateway). (Courtesy of Mallie and Glenn Ireland.)

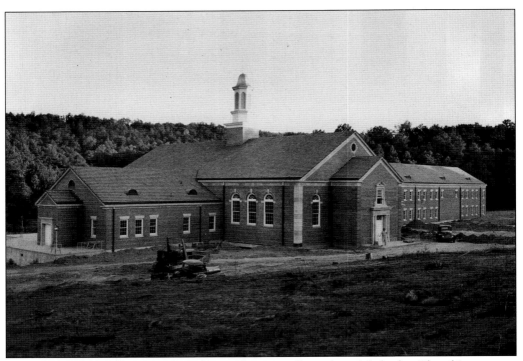

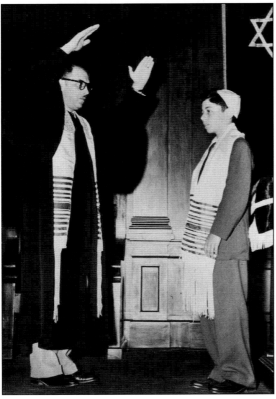

Canterbury Methodist Church's new location is pictured nearing completion in 1951 after the church merged with Union Hill Methodist Episcopal Church. It had formerly been Mountain Brook Methodist Church, originally constructed in 1912 in Crestline. The first service at the Overbrook Road location was on October 12, 1952, with 900 members. The site was formerly a cow pasture of Bearden Dairy. (Courtesy of Canterbury United Methodist Church.)

While the majority of Birmingham's Jewish community lives in Mountain Brook today, their origins were on Birmingham's north side, dating back to the late 19th century. Jewish merchants started most of Birmingham's department stores, like Loveman's, Blach's, Pizitz, and Parisian. Jews migrated in the early 1900s to Southside, and, after World War II, started moving over the mountain. Knesseth Israel, the more traditional Orthodox congregation, moved to Montevallo Road in 1955, as pictured here during a Bar Mitzvah. (Courtesy of Larry Brook.)

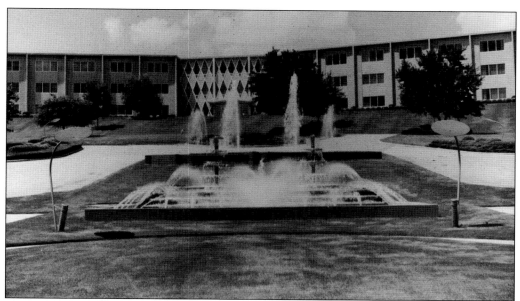

Ervin Jackson and his brother Philip, along with investor N.H. Waters, had enormous vision and courage, just like Robert Jemison did in the 1920s. They did something monumental by developing the first office park in the United States in 1955. They decided if industrial factories could have complimentary parking for employees and visitors, why not offices? To avoid creating concrete jungles, no building could be higher than a basement and two stories, nor could it occupy more than 25 percent of the lot, assuring ample parking and beautiful landscaping. No tenant could display their products. Mountain Brook established new zoning for an office park, which was replicated all over the country, providing a different atmosphere for office workers. Many real estate books officially recognize Mountain Brook's office park as the first in the nation. The photograph above was taken in 1962. Pictured below is the Vulcan Materials home office, constructed in the office park's Building No. 1 in 1955. (Both courtesy of Ivey Jackson.)

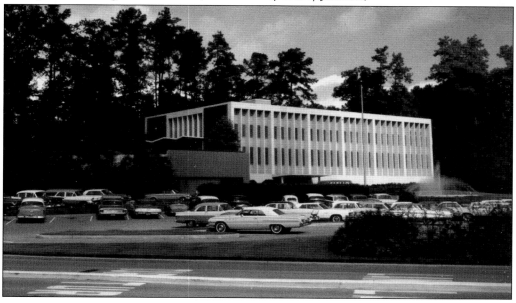

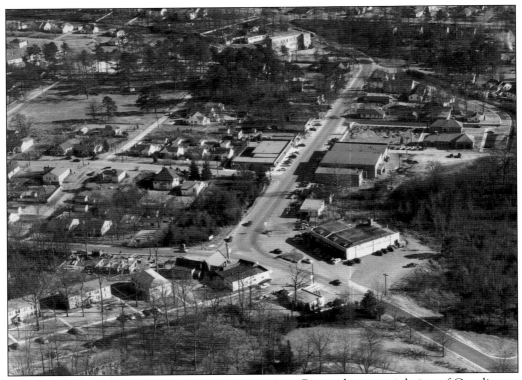

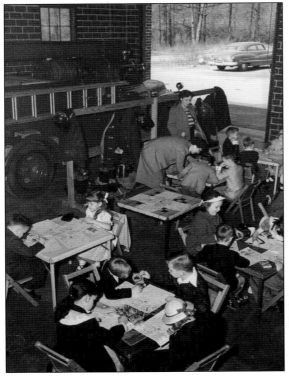

Pictured is an aerial view of Crestline Village in 1950–1951, after the city hall and the police and fire departments had been built. Ariail's Drug Store and Hill's Grocery are visible in the foreground. The property between St. Luke's Episcopal Church and Ariail's had been pastureland. In 1955, Crestline Heights added a new shopping center on Oak Street that adjoined the new city hall. Seven new stores were added. Later, the shopping center housed a teenager favorite, Pasquale's Pizza, in the 1970s. (Courtesy of CMB.)

The St. Luke's congregation quickly outgrew its new church, and held Sunday school classes at the old wood-frame firehouse in 1949. Pictured in the new brick fire station in 1951 are Sunday school teachers giving instruction, while also warning the children not to climb on the trucks. They also met on the porch of the church, outside in the yard, and all around Crestline. (Courtesy of St. Luke's Episcopal Church.)

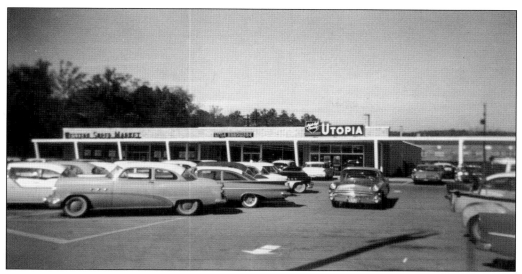

In the first 15 years since its incorporation, Mountain Brook tripled in size, both geographically and in population. Mountain Brook Village experienced more retail growth and development, such as the Mountain Brook Shopping Center, developed by Rele Evans and Ervin Jackson, which opened in 1955. It was home to great restaurants and retail and grocery shopping, such as Britling's Cafeteria, Utopia Cleaners, Little Hardware, and Western Super Market. (Courtesy of CMB.)

Families began moving to the Abingdon area from the Mountain Brook Village area in the late 1940s and early 1950s. Architects Nelson Smith and Sprott Long designed many homes built by these families. The Dunn, Shaw, Yeates, Turlington, Miller, Blackwell, McGriff, Wilson, Ireland, Frank Bromberg, and Herbert Smith families were among the first who moved there. Pictured is Bibby Smith on Sapphire, the McGriffs' donkey, who led the Fourth of July parade every year. (Courtesy MFC.)

Meg McGriff and Laurie Miller play dolls in the side yard of the Miller home in Abingdon. Laurie's parents, Olivia and William "Jig" Miller, lived on Camellia Hill, the family compound with the Turlington and Blackwell families. The children all played interchangeably in each other's yards, roamed the family compounds, assumed that they were all cousins, and referred to all grown-ups as "aunt" and "uncle." (Courtesy of MFC.)

Across the fields of clover in Abingdon, several families regularly got together to picnic in the dell. This family had rather unique transportation to the neighborhood gathering, with their horse, Dude, leading the way. When Dude died on Christmas Day in 1962, many of the Abingdon families came together to help dig the grave and give him a proper burial, singing the doxology over the grave. (Courtesy of the Dunn family.)

In 1953, Dr. Frank and Emily Wilson moved their family to Abingdon, at 4212 Caldwell Mill Road (Dunleigh) when Beverly and Billy Dunn moved next door to Oakland (4200), built by his parents, Lucy and William Ransom Johnson Dunn. Elsie and Joe Conzelman bought Dunleigh in 1963, and the Wilsons moved nearby to the "Box House," built by their son, Billy "Watlo" Wilson, a well-known portrait artist. (Courtesy of TFC.)

Known as Trapper John McIntyre in the classic 1970s comedy series M*A*S*H, William Wayne McMillan Rogers III grew up in Abingdon and attended Ramsay High School. He told people he was from New Merkel instead of Mountain Brook. A 1954 graduate of Princeton, he served in the Navy before pursuing acting. He is now chairman of the board and co-owner of Kleinfeld Bridal, as well as chairman and president of Wayne Rogers & Co. (Courtesy of Wayne Rogers.)

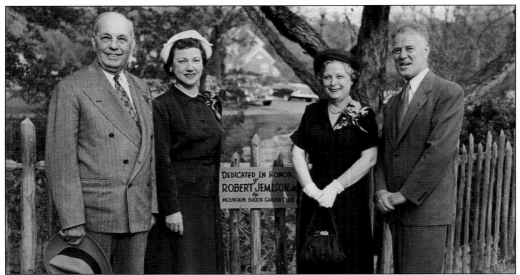

In 2014, Mountain Brook was named a Tree City USA for the 20th straight year. With over 92 percent of the city under tree cover, it has one of the highest ratios in the nation. Because of the strict zoning laws established by the city, the natural landscape has remained intact. In 1952, Jemison Park was dedicated in honor of Robert Jemison, who "conceived and created his masterpiece." Pictured here from left to right are Jemison, Mrs. W.C. Parsons, Mrs. D.O. Nichols, and Mayor Zukoski. The Mountain Brook Garden Club sponsored the project. (Courtesy of JFC.)

John Murdoch Harbert III and Marguerite "Wita" Jones were married in June 1951 at St. Mary's-on-the-Highlands Episcopal Church. Their wedding reception was hosted at her parents' home on Pine Ridge Road. Pictured clockwise from bottom left are Joan McCoy, Olivia Miller, Ed Dixon, John and Wita Harbert, Bill Harbert, Alice McCullough, Anne Ballard, Bamie Edwards, Anne Shaw, and Pete and Acky McGriff. (Courtesy of MFC.)

Mountain Brook was thriving after World War II, and life became simple again. Mr. McKay, the milkman, delivered the milk, butter, and eggs, and children played in the sprinkler in their yards and walked or rode their bicycles to Crestline Village to get a burger or ice cream at Ariail's, or to shop at Mitzi's Second Place. Pictured are Bill and Pam Tilly. (Courtesy of Peggy Montgomery.)

Stringfellow Farm, as it was commonly called in the 1940s and early 1950s before being developed as Lake Drive, was a working farm with a horse exercise track. The Stringfellow family also had a farmyard full of chickens, monkeys, mules, and peacocks, making it a popular place for neighborhood children. Pictured in front of the barn is Mary (standing), who instructed riders and helped take care of the horses. (Courtesy of Bee and Walter Morris.)

The 1950s were a much more carefree time than the previous decade, a time of war and sacrifice, had been. Weddings were celebrations, and many receptions were held at the bride's home, providing a more personal, intimate venue. Married at St. Luke's Episcopal Church, known as "the Red Church," Katharine "Kitty" Lynch Moughon celebrated her nuptials to Dr. Gordon Robinson with their guests at her parents' Pine Ridge Road home. Pictured from left to right are Jack Trigg, Hugh Morrow, the bride, Mrs. Nab Drennen, and Eddie Munger. (Courtesy of RFC.)

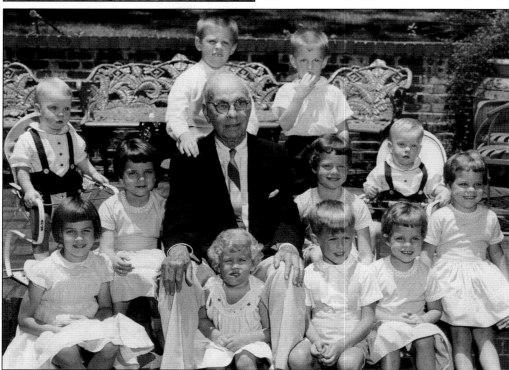

The "Great Granddad," Robert Jemison, is pictured here with 11 of his 15 great-grandchildren to celebrate Father's Day in 1958. From left to right are (seated on front step) Ann Smith, Joan and Jack Lacy, and Kate Johnson; (second step) Wilson Smith, Studie and Walker Johnson, Marshall Smith, and Nina Johnson; (standing in back) Montgomery and Lindsay Smith. They are the children of Mr. and Mrs. Crawford Johnson III, Mr. and Mrs. Lindsay Crawford Smith, and Mr. and Mrs. Alexander Sheldon Lacy. Missing are John Michael, Robert Berstrand, and Stephen Jemison Epps, the children of Mrs. and Mrs. John Stephen Epps of Huntsville, and Mary Jemison Grover, the daughter of Mr. and Mrs. Phillip M. Grover of Reading, Massachusetts. (Courtesy of JFC.)

During high school and college, "the great wall" at Birmingham Country Club was where the teenagers hung out during the summers before returning to school; they spent countless hours playing tennis and golf, swimming, and getting sun on the pool deck. Pictured from left to right are (seated) Joan Cabaniss and Henry Drake; (standing and facing camera) Gail Evans, Sidney Thames, and Forsyth Sellers. (Courtesy of Forsyth Donald.)

Traditions have always played an important role in this community. The neighbors on Mountain Park Circle have believed in letting the Christmas light shine since 1946. They formed a committee to plan the decorations for the circle with lighted trees and stars. This is a magical tradition that continues today. Pictured here are the Ireland, Barcroft, Vogtle, Bolvig, Vangelden, and Parker families as they gathered for a cocktail party to plan their festivities in 1951. (Courtesy of Ann Hicks.)

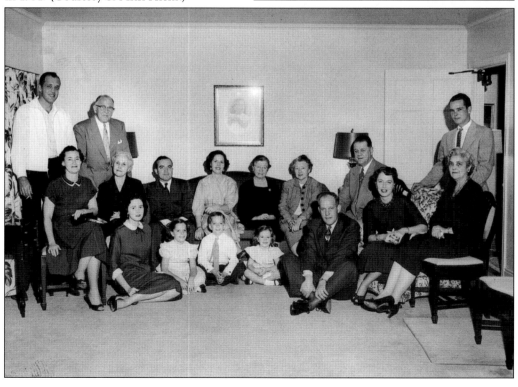

With World War II over, the 1950s brought growth and expansion. J.B. and Bentley Owens developed Lake Drive in 1952 after purchasing the property from the Stringfellows. Here, in 1957, (from left to right) Bent Owens III, Freddy Owen, and John Yielding fish in the small lake. The original caretaker's house on the property has housed three generations of the Owens family for over 60 years. (Courtesy of Fred Owen.)

After World War II, many Jews started moving into Mountain Brook. The Young Men's Hebrew Association bought 70 acres on Montclair Road and established the Jewish Community Center in 1959. Morris Sher and Louis Pizitz are pictured here at the dedication. It houses local Jewish agencies, like the Birmingham Jewish Federation and Foundation, that centralize fundraising efforts and needs worldwide, and the N.E. Miles Jewish Day School. Next door is Collat Jewish Family Services, which offers senior services, counseling, and emergency assistance. (Courtesy of Larry Brook.)

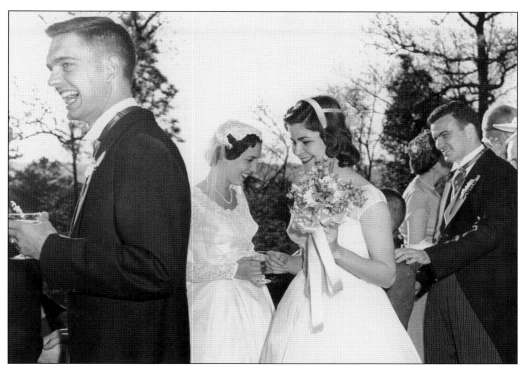

The area commonly known as Shook Hill was dubbed so because the original residents were members of the Shook family, who built on the bluff after World War I. Brothers Warner and Paschal Shook built first, and Mr. and Mrs. Jelks Cabaniss built in the 1920s. Annexed into Mountain Brook in 1961, the property was divided and other houses were built, most of them with a connection to the Shook family. Jane Comer and Alfred Montgomery Shook hosted their daughter Catherine's wedding reception at their Shook Hill home in 1957. Pictured from left to right are Buzzy Matthews, Catherine Shook, Forsyth Sellers, and Joe Donald. The latter two married a year later. (Courtesy of Forsyth Donald.)

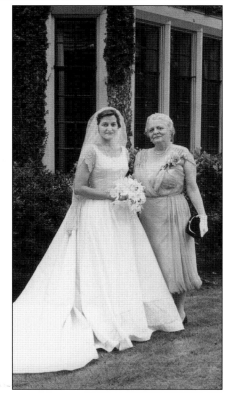

Recruited by Tennessee Coal Iron and Railroad Company in 1912, Dr. Lloyd Noland, who had helped eradicate yellow fever in the Panama Canal, established Alabama's first public health and industrial medicine program in Fairfield. His brother Cuthbert P. Noland followed him to Birmingham and married Augusta Clark after World War II. They moved to Balmoral Road into a beautiful stone house originally built for Col. William Rushton. Pictured are Augusta Noland and her daughter Rosalie at Rosalie's wedding to George Gambrill in 1959. (Courtesy of Ro Holman.)

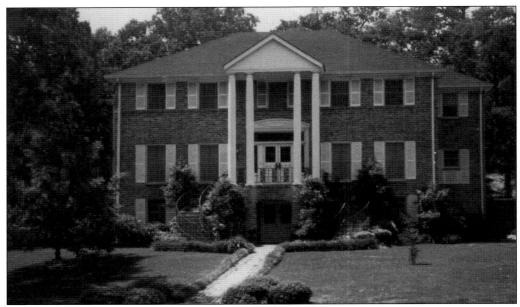

At the entrance of Cherokee Bend, Leonard Sterne built this handsome, brick Colonial home in 1966 on Old Leeds Lane. He and his wife, Gertrude, lived there with their daughters, Trudi and Suzanne. Sharp and Louise Gillespy bought it in 1970 and made it a center of family entertaining and activity in Cherokee Bend for their children, Sharp IV, Clark, Patti, and Lee, as well as their many friends. (Courtesy of GFC.)

Margaret Pride (Rutland) and James O. Finney built on Stone River Road in Cherokee Bend in 1968. Pictured are Pattie Perry and Jimmie Finney in front of his parents' home. Laurie and Will Hereford bought the home in 1993 and sold it to her brother and his wife, Nancy and David Faulkner, in 2001. The home in the background belonged to Anita and Billy Hamilton and is now owned by Katherine and Trip Galloway. (Courtesy of Pattie Perry and Jimmie Finney.)

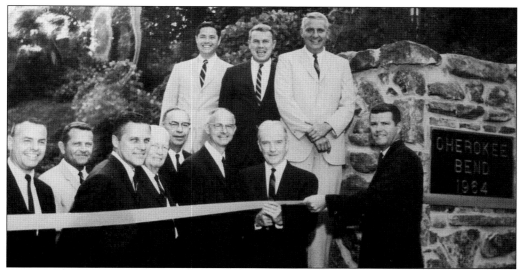

Hamilton "Ham" Perkins Jr. returned from US Naval service in 1955 to develop real estate like his father, grandfather, and great-grandfather. Perkins envisioned developing a large tract of land adjacent to Cherokee Road, the last road Robert Jemison developed. Perkins sought advice from Jemison, who commented that the area "was at the bend in Cherokee Road, a billy goat hill." With Jemison's blessing, Perkins named it Cherokee Bend. Pictured from left to right in 1964 are (first row) John Davis, Vann Perkins, Ham Perkins, Elliott Belcher, Robert Jemison, Red Terrill, Jerry Drennen, and unidentified; (second row) Felix Drennen, Mel Davis, and Ted Holder. (Courtesy of Charles Perkins.)

Architect Nelson Smith designed the new home of St. Luke's Episcopal Church. After Bishop Carpenter consecrated the grounds, construction began in 1961 on Montrose Road, as pictured here. The church has played an integral role in the Mountain Brook community, offering Christian education through preaching, Episcopal Youth Community, and vacation Bible school. The church established a Mother's Day Out program and has also provided meeting space for Scout troops and others for many years. (Courtesy of St. Luke's Episcopal Church.)

Brian Kimerling is pictured at his Bar Mitzvah in 1958 with his parents, Paula and Joseph. Max and Tillie Kimerling, Joseph's parents, built at 2921 Overhill Road in 1935. Many Jewish families, such as the Abroms, Engel, Bayer, and Hess families, have been patrons and benefactors of the cultural community in Birmingham, including the Birmingham Museum of Art, the Birmingham Symphony Orchestra, the Alys Stephens Center, and, more recently, the Abroms-Engel Institute for the Visual Arts. (Courtesy of Jon Kimerling.)

With Jews restricted from local country clubs at the time, they established the Progress Club in 1920, which later became the Fairmont Club in 1944 and was located on Shades Creek Parkway, where the Protective Life Building is today. In 1969, it merged with the Hillcrest Country Club (originally established as the Phoenix Club in 1883) to form Pine Tree Country Club, which opened its membership to non-Jews in 1991. Pictured are Sol Kimerling (back left) and Judge Marvin Cherner and his wife, Leona (front center), in 1958 at the Fairmont Club. (Courtesy of Jon Kimerling.)

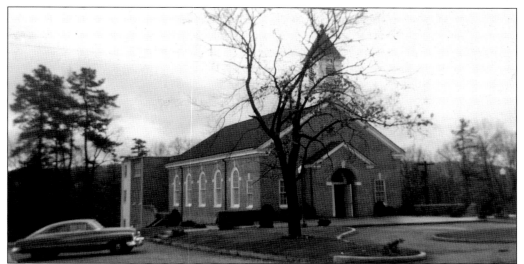

Originally called Valley Baptist Church, Mountain Brook Baptist Church was organized in 1944, during World War II. Due to gas rationing, churchgoers could not afford to drive downtown, so they organized closer to home and met at Crestline School. The chapel was the first building, constructed in 1951 on Montevallo Road, with an education building added in 1954–1955. It was not until 1967 that the first services were held in the new sanctuary. (Courtesy of Birmingham Public Library Archives.)

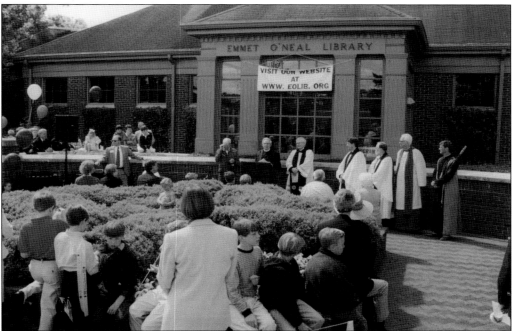

On the grounds of the former Herrin farmhouse, Emmet O'Neal Library opened its doors in 1965. Elizabeth and Kirkman O'Neal donated the funds to build the library and named it in honor of his father, Emmet O'Neal, who served as governor of Alabama from 1912 to 1915. It serves as the center of the community. Here, the St. Luke's Episcopal Church congregation celebrates its 50th anniversary on the grounds where it first began. (Courtesy of St. Luke's Episcopal Church.)

Pictured in Del and Jack Krueger's backyard are Ham Perkins and his wife, Margie (Collins). Because of his military background and love of history, Perkins named all the streets in his 1964 Cherokee Bend subdivision after battles of the Civil War. Later, he went on to develop the Belle Meade and Knollwood subdivisions. (Courtesy of KFC.)

Cherokee Bend School opened on September 2, 1969. Janice Wolfe was the first principal. Architect Nelson Smith designed the school, and Brasfield & Gorrie was the contractor. With lots of support from the new parent-teacher association, moms held book drives to help stock the library, and garden clubs helped beautify the school grounds. A total of 203 families contributed $5,185 to the educational fund to help provide necessary equipment. (Courtesy of Dicky Barlow.)

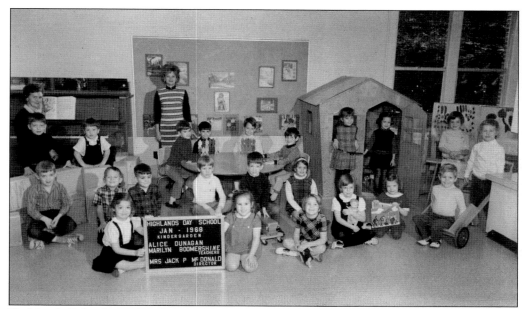

Highlands School was founded in 1958 as an expansion of The Bunny Hole, a nursery school established by Evalina Brown Spencer. Highlands Day School, as it was originally named, was incorporated in 1958 and rented space at St. Luke's Episcopal Church to hold its first classes. In 1962, the school relocated to its present site thanks to a generous donation of 12.5 acres by Joseph W. Simpson. (Courtesy of Pattie Perry Finney.)

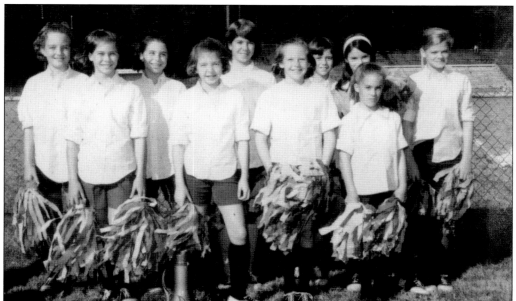

In 1968, the fifth-grade cheerleaders at Highlands Day School cheer on the football team, which was playing at Shades Valley High School. Pictured from left to right are Melissa Berry, Betsy Hill, Trudy Williams, Anne Emack, Louise Sewell, Sidney Quarles, Luann Gravlee, Georgia Miller, Joy Maulitz, and Margaret White. The girls made their own pompoms. The parents joked that there were more cheerleaders than football players. (Courtesy of Ben Jackson.)

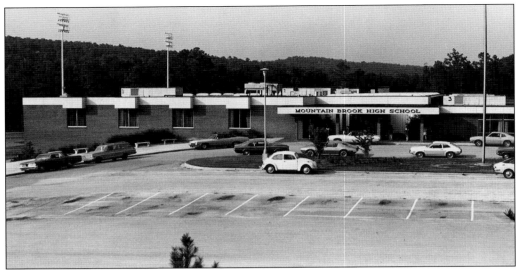

Mountain Brook High School (MBHS) opened in 1966 on property that Ham Perkins donated. Ranked as one of the best high schools in the state, over 500 MBHS students have been named National Merit Finalists, and three Rhodes scholars have graduated from the high school. In addition to MBHS, Mountain Brook Junior High School, Crestline Elementary School, and Brookwood Forest Elementary have been recipients of the Blue Ribbon School Award. *Newsweek* magazine recognized MBHS as one of the nation's top 100 high schools. It has won 122 state athletic championships in its 40-year history. (Courtesy of CMB.)

Sorority rush was the height of summer fun for young girls as they drove by friends' houses honking their specific sorority honks. There were five sororities by the mid-1970s: Theta Kappa Delta (ΘΚΔ), Alpha Delta Psi (ΑΔΨ), Phi Kappa Nu (ΦΚΝ), Alpha Theta Delta (ΑΘΔ), and Delta Kappa Phi (ΔΚΦ). Pictured at Eastwood mall for a ΘΚΔ rush party are, from left to right, Dorothy Shaw, Amanda Neal, Ann Nelson, Meg McGriff, Kappi White, Sully Given, and Wilma Cox. (Courtesy of MFC.)

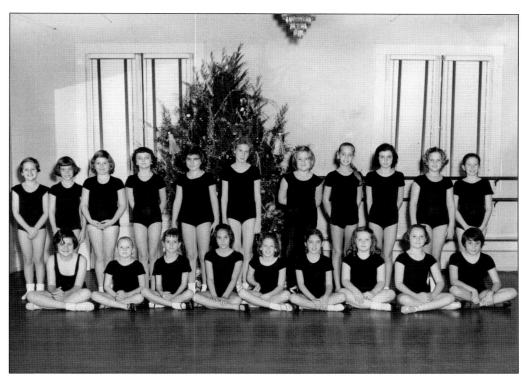

Ballet classes have always been a tradition, and Miss Nancy Lum's dance classes were popular for many Mountain Brook girls. The recitals were held at the Phillips High School auditorium in the 1960s. Pictured here from left to right are (first row) Nelle Waite, two unidentified, Cynnie Shook, Fran Sherrill, Beverley Nabers, unidentified, Meg McGriff, and unidentified; (second row) Pam Thuss, Laurie Miller, Katey Seibels, unidentified, Carmen McAdory, Jane Mackey, Katherine Hicks, Betty Noojin, Greer Knapp, Sarah Miree, and Lynn Odess. (Courtesy of MFC.)

For 23 years, the Lola Mae Jones School of Dance was located upstairs above Browdy's, in one of two buildings in Mountain Brook Village. In 1958, Mrs. Jones bought the former "Red Church" in Crestline and started dance classes there. Her daughter, Lola Mae Coates, continued the family tradition for many years. Many Mountain Brook children still take ballet, tap, jazz, and ballroom dancing classes there. (Courtesy of St. Luke's Episcopal Church.)

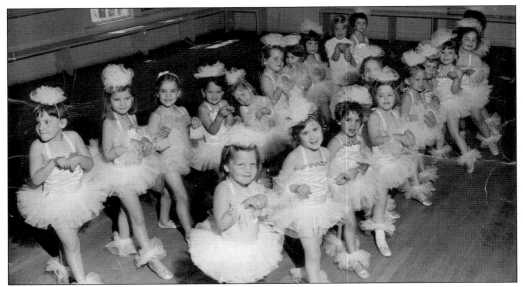

Another popular place to take ballet was the Pink House in Crestline. Originally owned by "Miss Patty" Tate, she taught dance classes in association with the Birmingham Ballet. Pictured here in 1969 are the four-year-old "Poodles," including, from left to right, (first row) Laurie Faulkner, TuTu Somerville, Margaret Hunter, Lillian Wiley, Melanie Somers, Laura Gilmore, Meme Boulware, Tina Young, Betsy McElroy, and Kittie Hillhouse; (second row) unidentified, Laura Pearce, unidentified, Katherine Bentley, Catherine Pittman, Alice Powell, Dootsie Evins, two unidentified, and Kathryn Donald. (Courtesy of Catherine Pittman Smith.)

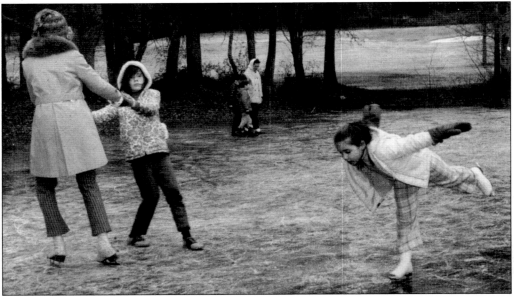

Birmingham does not see much snow, but in an unusual snow and ice storm in 1970, the Mountain Brook Club golf course became an overnight skating rink for children, parents, and grandparents alike. Pictured are both ice skaters and sliders showing off for a *Birmingham News* reporter. Margaret Finney (right) showed Laura and Leslie Woodberry (left) how it was done. (Courtesy of Pattie Perry Finney.)

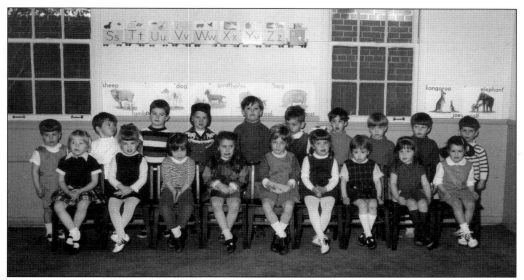

Many children attended Mother Goose Kindergarten, located at 27 Church Street in Crestline, which was started by Suzy Johnson and Vernon Whitney in the late 1940s and later became the preschool program at Mountain Brook Baptist Church. Pictured here in 1969 are, from left to right, (first row) Kristi Friday, Patti Miller, Susan Hunt, Elizabeth Minor, Karen Wood, Camille Fuller, Jane Stelzenmuller, Monica Kovac, and Marlin McWilliams; (second row) Jay Wilson, Jimmy Creamer Jr., Kelly Byrne, Jimmy Andrews, Chuck Tarter, Charles Shook IV, Tracy Faulk, Braxton Knott, Timmy Groover, and Russ Ashley. (Courtesy of Patti Ireland.)

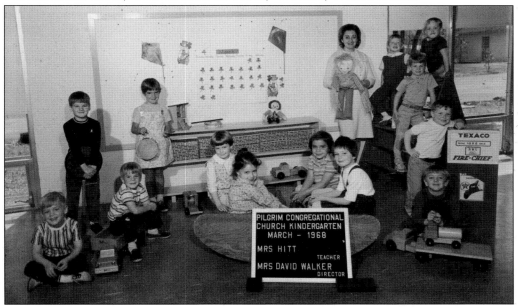

Commonly known as the "Blue Roof Church," Pilgrim Congregational Church had a three-, four-, and five-year-old kindergarten program located on Montclair Road near Crestline Village. In addition to the regular curriculum, they taught French, music, and creative movement. Alice Walker was the first director. It was torn down to build a new development of homes in 2009. (Courtesy of Bee Morris.)

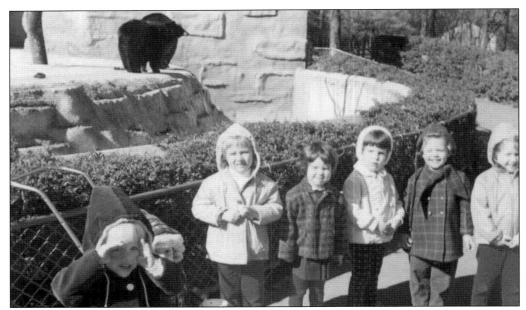

The first postwar support for a new zoo came in 1946. Monkey Island, the zoo's first official exhibit, was dedicated on April 2, 1955. The zoo was built on 50 acres with a budget of $250,000. Pictured here in front of the grizzly and polar bear exhibit in 1969 are, from left to right, Meme Boulware, Kitty Carruthers, Susan Emack, Laurie Faulkner, Nancy Shugerman, and Nancy Rutland. (Courtesy of Laurie Hereford.)

Mona and Susie, the zoo's first elephants, arrived in 1955, the same year the Birmingham Zoo, once known as the Jimmy Morgan Zoo, opened. Children have always been excited when visiting the zoo. The elephant, hippopotamus, and buffalo exhibits were always fun, as well as feeding the fish in the ponds and riding the train through the tunnel. Pictured is the Krueger family; clockwise from lower left are Jay, Jack, Del, and Billy. (Courtesy of KFC.)

Mountain Brook's gated community of Lockerbie takes its name from the original home on the 70-acre property. Now owned by George Gambrill Lynn, Lockerbie was built by Forney Johnston in 1932. It is the only work in the Deep South of Classical Revival architect William Lawrence Bottomley of New York. Johnston, founder of the Birmingham law firm Cabaniss Johnston, was the son of Joseph Forney Johnston, Alabama's 30th governor (1896–1900) and a US senator (1907–1913). (Courtesy of George Lynn.)

Originally built in 1928, Dr. Jerome Chapman purchased this beautiful Mount Vernon Colonial–style home on Montevallo Road, just outside Mountain Brook Village, for $15,000 in 1935 during the Depression. Louise and Sharp Gillespy bought it in 1963. Lynn McGovern Grimsley purchased it in 1971, and Hill Sewell owned it from 1996 to 2010. Margaret and Peter Lichty now own the home. (Courtesy of GFC.)

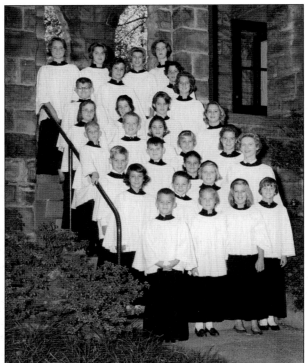

Many children who lived in Mountain Brook were active in their church youth groups and choirs. Pictured in 1963 is the St. Mary's-on-the-Highlands Church junior choir, including, from top to bottom, (left column) Meg McGriff, Alex Nuckols, Jane McGriff, Miles Hazzard, Lloyd White, Suzanne Pettus, and Dan Owens; (second column) Catherine Monaghan, Jody Owens, Anne Smith, Henry Schley, John Nuckols, Ray Landis, and Margaret Yeates; (third column) Ellen Davis, Ann Monaghan, Frances Whitaker, Mary Yeates, Greer Miric, Lanier Ager, and Tina Shannon; (right column) Marietta Monaghan, Mary Givhan, Betsy Abele, Rutledge Forney, Susan Givhan, Mrs. Sue Brown, and Helen Rosa Monaghan. (Courtesy of MFC.)

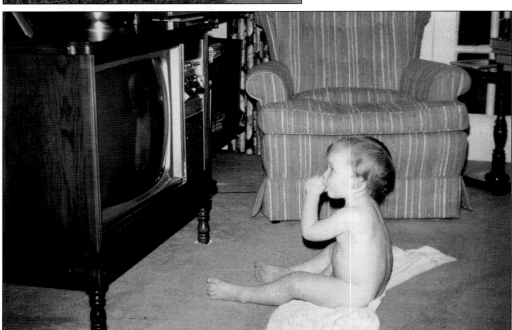

Growing up in the late 1960s and 1970s, television was the main source of in-home entertainment. Programs such as *Sesame Street* and *Mr. Rogers' Neighborhood* were quite popular with children. William Shields Tynes is pictured with his favorite "blankie" in front of the family's Motorola television watching Arthur Fiedler, conductor of the Boston Pops Orchestra, on PBS. (Courtesy of TFC.)

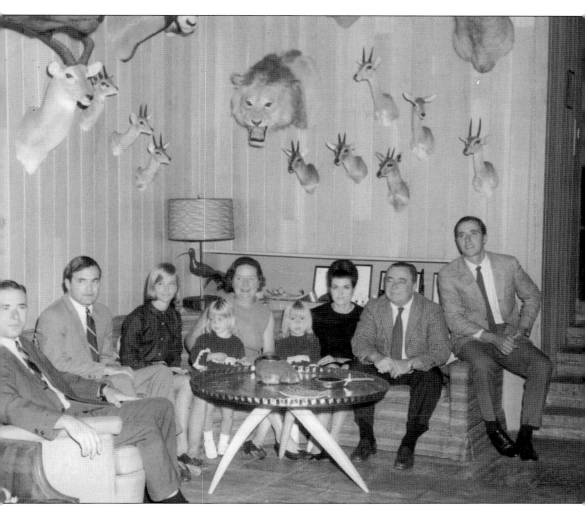

Allan Harvey "Rick" Woodward Sr., chairman of Woodward Iron Company and the grandson of pioneer Birmingham industrialist Stimpson Harvey Woodward, was married to Robert Jemison's sister Annie. Woodward purchased the Birmingham Coal Barons baseball team, a Negro League team, in 1909, and then built Rickwood Field in 1910. Pictured is his son Allan Harvey "Al" Woodward Jr. and his family. From left to right are Nicholas Thurlow "Nick" Woodward, Robert Jemison "Rob" Woodward, Elizabeth Thurlow "Bimi" Woodward, Mary Elizabeth "Bunny" Woodward, Elizabeth "Becky" (Thurlow) Woodward, Mary Barbara "Pat Pat" Woodward, Patricia "Patti" (Swofford) Woodward, Allan Harvey "Al" Woodward Jr., and Allan Harvey "Rick" Woodward III. Al and Becky Woodward built the first home designed by Birmingham architect Sprott Long in Mountain Brook in 1952 on Cherokee Road. Worldwide travelers with a passion for hunting, the Woodwards also built a "trophy house" next door (pictured) to house their game mounts in 1962. There were many lively parties held there. (Courtesy of Bimi Cox.)

Developed in the 1960s, the Knollwood subdivision was located off of Overton Road. Actress Courteney Cox grew up there, and, down the street on Brook Hollow Lane, Bobby and Melanie Parker lived with their four children. Pictured on their backyard jungle gym in 1967 are, from left to right, Melanie, Frances, Katherine, and Robert. (Courtesy of Bobby and Melanie Parker.)

In 1959, the Mountain Brook school system was established with the purchase of Crestline and Mountain Brook Elementary Schools and Mountain Brook Junior High School. In 1964, Brookwood Forest School was built, and the neighborhood surrounding it quickly followed suit. Pictured is a Springhill Road home under construction and nearing completion. Davis & Major built many of the Brookwood Forest homes. (Courtesy of KFC.)

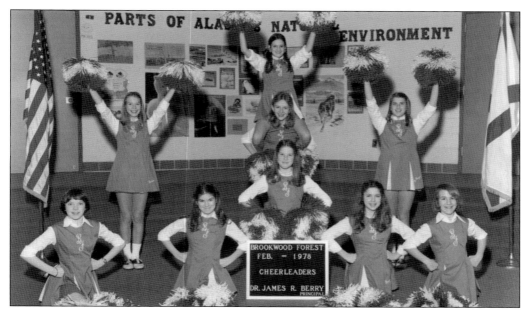

Brookwood Forest School was built in 1964. Each of the elementary schools had its own football and basketball teams, which the student body cheered on. Pictured are the seventh-grade Ranger cheerleaders in 1978. From left to right are (first row) Kristi Tingle, Jamie Wilcox, Bunny Woodward, and Jill Gotleib; (second row) Jeannie Shingleton, Sandy Bolen, Nancy Hand, Susan Robeson, and Mary Virginia Knight. (Courtesy of Mary Virginia Cater.)

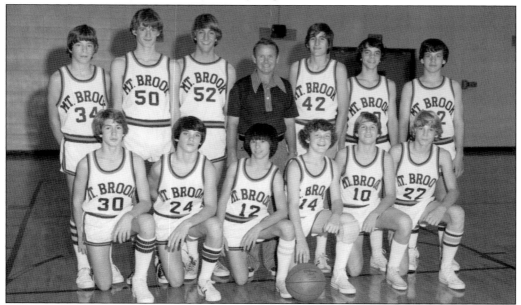

Mountain Brook Junior High School was built in 1957. Eighth and ninth grades were at the junior high school from 1969 until 1980, when the seventh grade returned. This Bruins eighth-grade basketball team included, from left to right, (first row) Jimbo Walker, Charles Perkins, Richard Chen, Dugan Prater, Robert Cole, and Scott Farr; (second row) Billy Krueger, Steve Wilkes, Art Price, Coach Cox, Jim Poist, Kirk Mogge, and Rob Mann. (Courtesy of KFC.)

George Gambrill III, a noted home and garden designer in Mountain Brook and throughout the South, studied landscape architecture at the American Academy in Rome. His work included private residential projects, as well as designs for the Birmingham Botanical Gardens, the Birmingham Museum of Art, and Mountain Brook's first gated community, Cross Creek Park. Built in the late 1970s, Gambrill designed the elegant perimeter wall and guardhouse in addition to several of its homes and gardens. (Courtesy of Ro Holman.)

Mountain Brook was the first city in Alabama to employ a city manager, in 1942, and the first to utilize the council-manager form of government. The mayors of Mountain Brook through the years were Charles F. Zukoski, 1942–1955; David W. Hamilton, 1955–1959; Samuel H. Burr, 1959–1961; Robert M. Goodall Jr., 1961–1964; William M. Given Jr., 1964–1968; Allen D. Rushton (pictured), 1968–1972; Lee "Pete" McGriff, 1972–1980; T. Allen Gaskin Jr., 1980–1984; William M. Given Jr., 1984–1992; William E. Matthews IV, 1992–1996; Margaret Porter, 1996 (six-month term); and Lawrence T. Oden, 1996–present. (Courtesy of CMB.)

In 2011, the City of Mountain Brook demolished its municipal complex, originally built in 1950. Designed by Williams Blackstock Architects, the new facilities, including the city hall and the police and fire departments, were completed in 2013. Pictured here is city hall, situated on Church Street in the heart of Crestline, a village that still maintains its small-town feel reminiscent of its past. (Courtesy of Catherine Pittman Smith.)

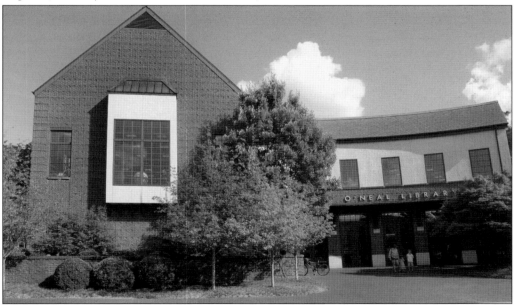

In 1993, the Emmet O'Neal Library Foundation was established. It raised $8 million to fund a new public library, which was completed and opened in 2001. The Friends of the Emmet O'Neal Library host an annual book sale that raises money to support children's programming. The library serves as a cultural and learning center for the Mountain Brook community in the heart of Crestline. (Courtesy of Catherine Pittman Smith.)

In 2015, Lane Parke will begin replacing the existing Mountain Brook Shopping Center, which was opened in 1955, with new retail space. Originally developed by Rele Evans and Ervin Jackson, the shopping center has been home to many favorite restaurants, shops, and grocery stores through the years, including A'Mano, Browdy's, Gary Rexall Drugs (Rite-Aid), Little Hardware, the Dandé Lion, Smith's Variety, and Western Super Market. The new facility will include 68,000 square feet of boutiques, specialty retail stores, and restaurants in the heart of Mountain Brook Village. (Courtesy of Catherine Pittman Smith.)

A cooperative effort between Evson Inc. and the Daniel Corporation, the 28-acre Lane Parke development is moving historic Mountain Brook into the future while honoring its legacy. Park Lane Apartments, originally built in 1948, were torn down in 2013, and the first phase of construction began on the new exclusive apartment community in January 2014. The boutique Grand Bohemian Hotel Mountain Brook will be completed in 2015. (Courtesy of Catherine Pittman Smith.)

Three

LEISURELY LIVING
PARTIES, WEDDINGS, RECREATION, HOLIDAYS, AND TRADITIONS

Mountain Brook is a very social town, and its residents are known for hosting and enjoying glamorous balls, elegant weddings, and spectacular parties, with big bands and decorations to match. The German Club members, for instance, were known to host rather "lively" parties. Pictured here are Louise and Sharp Gillespy on a British Ariel square-four motorcycle as they ride into the 1963 German Club "Wild Ones" costume party at Birmingham Country Club (BCC). Afterward, the German Club was banned from having parties at BCC for 20 years. They moved their dance location to the Hollywood Country Club. (Courtesy of GFC.)

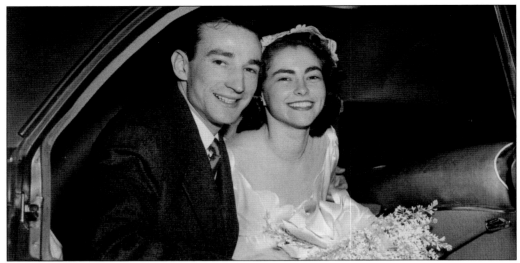

The wedding of Glenn Ireland and Frances Malvina "Mallie" Moughon was at the height of the social season in 1950. They married at the Church of the Advent and are pictured leaving their reception at Birmingham Country Club. They enjoyed a three-month European honeymoon, and upon their return home, they lived at Foxhall Apartments in Crestline. Mallie's gown has been worn by many other family members and friends. (Courtesy of Mallie and Glenn Ireland.)

The Beaux Arts Jewel Ball was started to help financially support the newly founded Birmingham Museum of Art in 1951. Some of the early Beaux Arts "royalty" were Key Foster Jr., William Tynes Jr., Emily Hassinger, Mary Dunn, Charlotte Rushton, Leon Edwards, Gail Evans, and Alfred Shook. Here, in 1959, Fairlie Arant is being crowned queen with her court at the Boutwell Auditorium. (Courtesy of TFC.)

Sallye Dewberry Martin began selling stationery and wedding invitations at Dewberry Engraving and quickly became involved as the "social secretary" for the Debutante Club of Birmingham. She evolved into the keeper of Mountain Brook's society calendar and dated the debutante parties that resulted in many marriages. She is seen here with her daughter Winston at Winston's wedding to Jack Carl in 1964. (Courtesy of Winston Carl.)

Since 1929, the Debutante Club of Birmingham has invited young ladies to make their debut to be presented to society at various balls throughout the debutante season. The Redstone Club celebrated its 50th anniversary at its annual Christmas ball in 1957, with John B. Cox as president. The debutantes wore white ball gowns and kid gloves and received the traditional Redstone gift, a silver bracelet set with amethysts. This tradition continues today. (Courtesy of Forsyth Donald.)

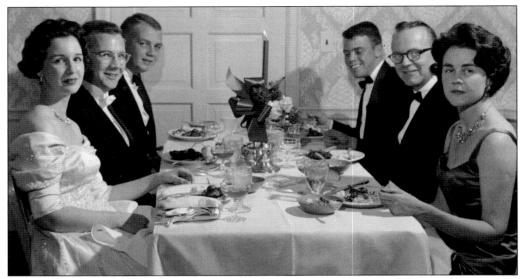

To celebrate the debutante season, there were many luncheons, teas, and dinners honoring the debutantes, hosted at Mountain Brook Club, Birmingham Country Club, or private residences. Seen here at a dinner party at Mountain Brook Club honoring Emily "Mimi" Wilson, Elizabeth Daniel, and Kitty Yancey before their debutante ball are, clockwise from front left, Elizabeth "Buffy" Daniel, Evans Dunn Jr., Henry Crommelin, Dicky Jemison, and John S. Jemison and his wife, Marie. (Courtesy of TFC.)

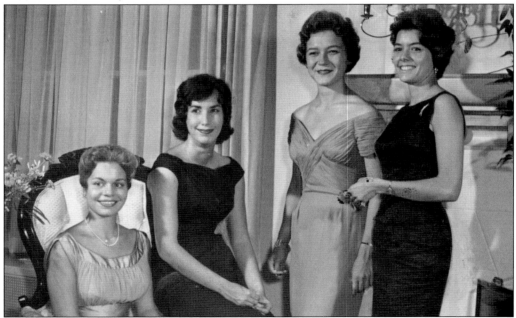

The debutante season of 1960 started with the annual luncheon given by Loveman's in honor of the debutantes at Birmingham Country Club. Pictured from left to right are Lucille Evans, Janie Bowron, Betty Bainbridge, and Linda Sue Parker. They were among 30 young debutantes presented at the 53rd annual Redstone Christmas ball. The president of the Redstone Club was William W. Jemison. (Courtesy of Linda Johnson.)

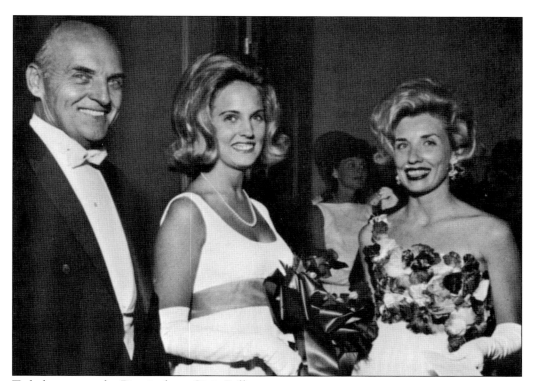

To help support the Birmingham Civic Ballet Association, members of the Ballet Guild of Birmingham decided to sponsor a large formal ball honoring the season's debutantes. The first Ball of Roses was organized and executed by the first ball chairman, Sue Anne Cole, in four months, with the help of Bette Anne Bargeron, Paula Crockard, Diana Walker, Carol Poynor, Ann Wilkerson, and Gordon McWhorter. A group of 13 Birmingham debutantes were presented in August 1961 at Birmingham Country Club. Pictured is guild president Kathleen Bruhn (right) in 1967. (Courtesy of Katie Patrick.)

Mrs. James Mallory Kidd Jr. organized the Beaux Arts Krewe, a men's club, in 1967, to support the Birmingham Museum of Art. The first ball was held in 1968. Pictured is Elesabeth Ridgely Shook, daughter of Barbara and Robert Shook, who was queen in 1981. Dr. S. Richardson "Dick" Hill was king. Kelle Thompson's Haute Couture Maison in Mobile designed Elesabeth's royal gown and train, which was later worn by queen Lenora "Nonie" Ireland Brown in 2013. (Courtesy of Winston Carl.)

Pictured from left to right are Katie Robinson, Mary Evelyn Bromberg, Trudy Williams, and Maggie Williamson at their debutante ball, "Ball de la Balloon," hosted by their parents, Kitty and Gordon Robinson, Joyce and Gene Bromberg, Bamie and Elliott Williams, and Jean and John Williamson. The party was held at Birmingham Country Club at Thanksgiving in 1979. The debutantes and their dates, as well as the many guests, danced to big band music. (Courtesy of RFC.)

In 1940, Mrs. Morris Bush started Holiday Assembly to teach high school girls proper social and dance etiquette. During their junior year of high school, Mountain Brook girls are invited to become members of Holiday Assembly. At the annual Christmas dance, the girls were originally presented with a silver pin (later a bracelet charm) inscribed with their initials, club name, and presentation year. Jim Stroud and Mary K. Quinn are seen here in 1951 at Mountain Brook Club. (Courtesy of Mary K. Wilson.)

Brooke Hill School, founded in 1940 by Mrs. George Blackburn, was a private, all-girls school for grades 5–12. The school hosted an annual father-daughter dance. Pictured here in the first row are, from left to right, ? Rankin, Jane Nabers, Virginia Murray, Din Cabaniss, Melanie Drake, Henley Haslem, Marcia Bush, Gordon Jackson, and Judy Cooper, with their fathers and grandfathers. The girls often wore beautiful peau-de-soie gowns, were given corsages, and wore white gloves. (Courtesy of Melanie Parker.)

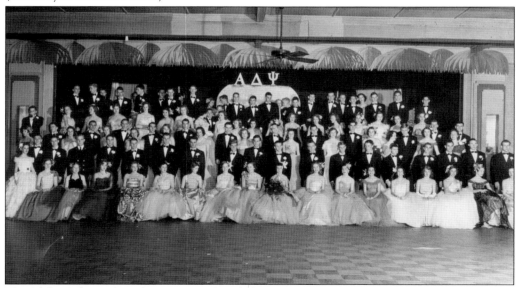

The Alpha Delta Psi (AΔΨ) sorority was founded in 1924 by Mary Jenkins Keith, Martha Henderson Goings, and Margaret Shannon McDonald. Pictured is the 1949 lead-out at the Pickwick Hotel. The officers of AΔΨ were Gayle Trechsel, president; Jane Ann Mitchell, vice president; Cynthia McCoy, recording secretary; Marietta Jones, corresponding secretary; Camille Walpole, treasurer; and Brevard House, rush captain. (Courtesy of Mary K. Wilson.)

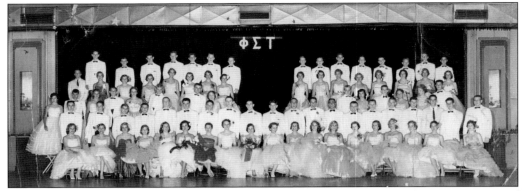

The Phi Sigma Tau fraternity was commonly called "Tau" among the teenage boys. Tau was one of seven fraternities. The others were Alpha Sigma Delta (Sigma), Chi Sigma Chi (Chi Sig), Kappa Theta Delta, Phi Delta Pi, Sigma Phi Omega, and Zeta Theta Epsilon. Their lead-outs were frequently held at the Pickwick Hotel and Highlands Country Club. (Courtesy of Jim Simmons.)

The early sororities in the Birmingham area were Delta Alpha Delta (ΔAΔ), Theta Kappa Delta (ΘKΔ), Alpha Delta Psi (AΔΨ), and Phi Kappa Nu (ΦKN). With teenaged girls attending different high schools, sororities provided venues for camaraderie and friendship. Pictured are Linda Sue Parker and Bruddy Evans in 1953 attending the AΔΨ lead-out. There were Jewish sororities as well. (Courtesy of Linda Johnson.)

CHI SIGMA CHI

36TH ANNUAL LEADOUT

JUNE 16, 1961 **9 P. M. – 1 A. M.**

CASCADE PLUNGE

DALE HAWKINS and HIS BAND

$1.00

The Cloud Room ballroom at Cascade Plunge was another favorite location for dances. Chi Sigma Chi fraternity held its 36th lead-out there in 1961. The large swimming pool surrounded by covered grandstands was fed by a natural spring, which "cascaded" from a tiered concrete fountain. The privately owned pool opened around 1925 and was, at the time, the largest in the area. (Courtesy of Sam Johnson.)

Theta Kappa Delta (ΘΚΔ) was originally founded as a school club and then became a sorority in 1925. Pictured are Bee Newman and her date, Hansell Peacock, at the ΘΚΔ lead-out in 1952, held at the Pickwick Club, which was popular because of its Five Points location. The officers were Nancy Williams, president; Miriam Jackson, vice president; Knoxye Johnson, treasurer; Gwen Gravlee, secretary; and Patty Camp, rush captain. (Courtesy of Bee Morris.)

The Mountain Brook Elementary School class of 1955 held its graduation dance at Vestavia Country Club. Pictured from left to right are Mardin Howle, Jane Stephens, Gene Hawkins, Betty Timberlake, M.D. Smith, Sally Marbury, Rick Woodward, and Margaret McCall. Afterward, they often went to Brookwood Road to drag race and gather on newly paved black asphalt, which they called "the black roads." (Courtesy of Betty Knight.)

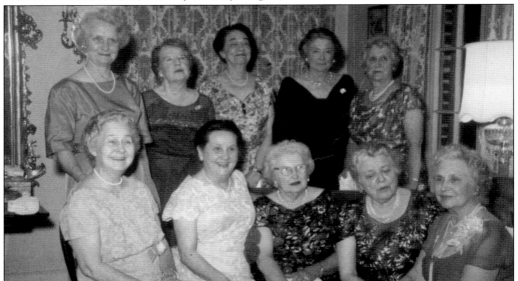

Mountain Brook housewives often combined their cultural interests with social affairs, a tradition that continues today. Many have literary, book, and sewing clubs. Pictured is a sewing club in the 1950s. From left to right are (first row) Eula Cross, Marguerite Jones, Helen Hettrick, Augusta Noland, and Lydia Rogers; (second row) Tatie Bell, two unidentified, Esther Seibels, and unidentified. (Courtesy of Ro Holman.)

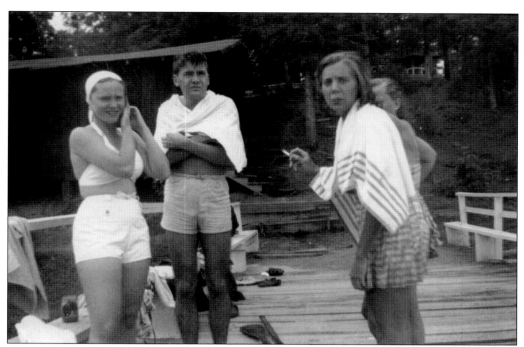

In 1922, the Redstone Club bought a 14-acre site on the Warrior River and established a clubhouse and cottages. For 40 years, the camp was a popular weekend venue for fellowship among club members and their families for fishing, boating, and swimming. The Redstone Club began as a fraternity, Phi Chi Delta, in 1908 and later transitioned into a young men's club, the Growler's Club and Community Club. It was eventually renamed the Redstone Club in 1927. Above, from left to right, Marguerite "Wita" Jones, Hopkins Coleman, and Caroline Jones enjoy an afternoon getaway at the Redstone camp in May 1946. At right, on the Fourth of July in 1961, Alice "Acky" McGriff (front) and friends enjoy the inner tubes in the Warrior River at the Redstone Camp. (Both courtesy of MFC.)

From the 1930s to the 1960s and even today, families have entertained in their backyards. Back then, they grilled out and had neighborhood cookouts; the children played with friends in sandboxes, swung on swing sets, and played hide-and-seek and sardines in the front yards. It didn't take a lot to entertain children. From washtubs and sprinklers to blow-up and plastic pools, they all provided great fun and entertainment. Pictured here is Mary K. Quinn in 1936 in the side yard at her family's Hastings Road home. (Courtesy of Mary K. Wilson.)

Sam Johnson (rear tub) is pictured in 1945 with his brother, Andy (standing), and Wayne Preston (front tub) playing in the sprinkler and in their mamas' washtubs in their Montrose Road backyard. (Courtesy of Sam Johnson.)

Peggy and Bill Tilly first raised their children on Cherry Street in Crestline, and later moved to Rockhill Road. Their son Bill is pictured here in 1953 in a blow-up pool playing with the hose in Mary and Jim Davis's backyard, with a laundry line in the distance. (Courtesy of Peggy Montgomery.)

Fences were not barriers for Catherine Pittman and Buffy Meador, her next-door neighbor. Building forts and catching crawfish in the creek that ran behind their houses were favorite pastimes. Catherine is pictured in her backyard on Dexter Avenue in 1969. (Courtesy of Catherine Pittman Smith.)

Walter Morris is pictured here in his driveway on Main Street in Crestline. He had just gotten his BSA motorcycle for his 13th birthday, and it provided great transportation for getting around town and going to friends' houses and to football practice at Crestline School. (Courtesy of Walter Morris.)

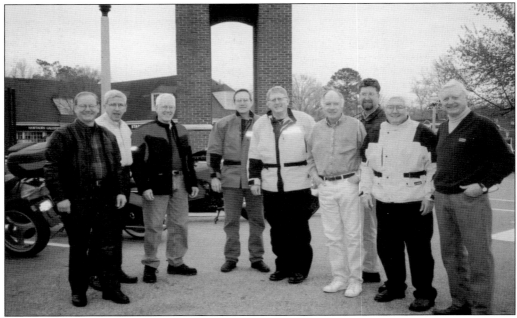

The "Nine at the Clock" motorcycle gang has been riding together for years. Headed to Mentone for a short day trip in 2001 are, from left to right, David Hood, Corky Rushin, Dick McLaughlin, Ed Stringfellow, Rick Kilgore, Thomas Boulware, Sam Williamson, Mickey Gee, and Sharp Gillespy. This biker group has ridden all over the United States, from coast to coast. (Courtesy of GFC.)

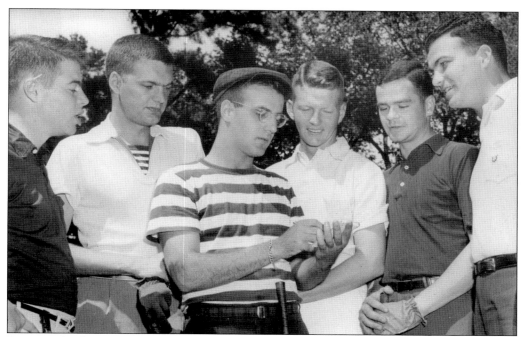

Because of college and military service, these lifelong friends had not played golf in a long time, but they were reunited at the Mountain Brook Club golf course during the summer of 1953. Their dogfight included, from left to right, Tommy Wilson, George "Buzzy" Matthews, William H. "B-Boy" Brantley Jr., Glenn Cobbs, Marvin Perry, and Joe Donald. (Courtesy of Buzzy Matthews.)

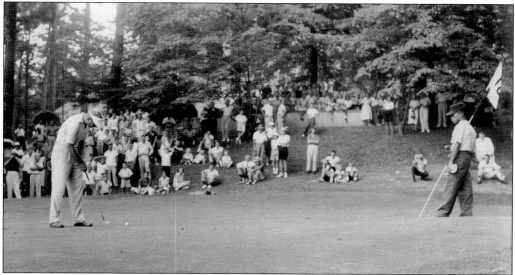

Elbert Jemison Jr., also known as Alabama's "Mr. Golf," putts his final shot for a 69, winning the 1957 state championship at Mountain Brook Club with his longtime caddy and friend, James Reynolds. Jemison won back-to-back state amateur golf titles and served as president of the Southern Golf Association. He later served on the US Golf Association's (USGA) executive committee, initiating the USGA membership program. He was inducted into the Alabama Sports Hall of Fame in 1982. (Courtesy of Anne Heppenstall.)

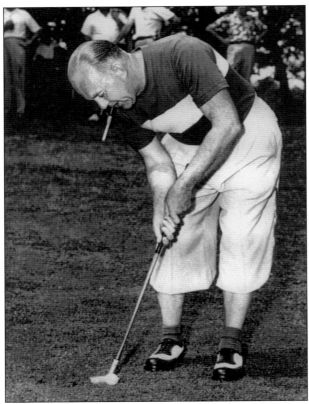

William Sanford Moughon, an avid golfer and longtime member of Birmingham Country Club, won the first BCC invitational golf tournament on June 15, 1930. He was inducted into the Alabama Golf Hall of Fame in 1978 in the company of many other BCC members. He played in the oldest dogfight, "the Rollers," at the club where his son-in-law Gordon Robinson plays today. He shot his age many times over. (Courtesy of RFC.)

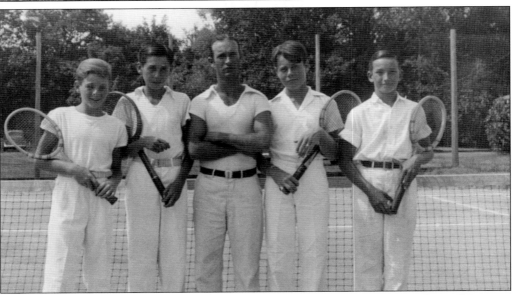

Pictured here with friends, Glenn Ireland (right) spent many of his summers at Camp Winnipeg in Eagle River, Wisconsin, with Prince DeBardeleben, Billy Smyer, Jimmy Shepherd, Jack Parker, and Crawford Johnson. One of their counselors was Paul "Bear" Bryant, before his tenure as head football coach at the University of Alabama. (Courtesy of Mallie and Glenn Ireland.)

Hubert Green, a longtime professional golfer who won 23 tournaments on the PGA Tour and the Champions Tour, grew up playing at Birmingham Country Club. He won two major championships, the 1977 US Open and the 1985 PGA Championship, and played on three Ryder Cup teams. He also won the Senior PGA Tour in 1998 at the Bruno's Memorial Classic, held at Shoal Creek. In 2007, Green was elected to the World Golf Hall of Fame. (Courtesy of Hubert Green.)

Jean Clarke Johnson learned the game of tennis at Birmingham Country Club. She was a star on the Southern Junior Tennis circuit during the war years, earning a number-one ranking in 1944. She won the Southern Women's singles title eight times and competed at Wimbledon in singles, doubles, and mixed doubles. One of the first players inducted into the Alabama Tennis Hall of Fame in 1985, she was posthumously inducted into the Southern Tennis Hall of Fame in 2001. (Courtesy of Catherine Pittman Smith.)

In the 1970s, a popular event at Highlands Day School was "Tacky Day." Pictured here are, from left to right, (first row) Laurie Faulkner, Sophie Bynum, Sybil Vogtle, TuTu Somerville, Susan Emack, Barbara Hicks, and Katherine Bentley; (second row) Susie Collat, Meme Boulware, and Kathryn Donald. They all were in the class of 1977. (Courtesy of Laurie Hereford.)

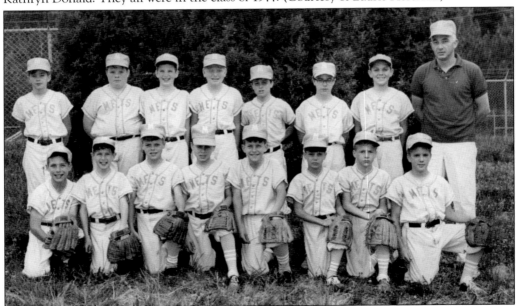

In 1968, baseball teams were associated with the YMCA, before there were elementary school teams. The Mets were city champions and were coached by Mike Murrell. This team included, from left to right, (first row) three unidentified players, Marc Routman, Gordon Robinson, Les Porterfield, Scooter Murrell, and Brian Ratliff; (second row) unidentified, Stewart Miller, Brooke Ruach, four unidentified players, and Coach Murrell. (Courtesy of RFC.)

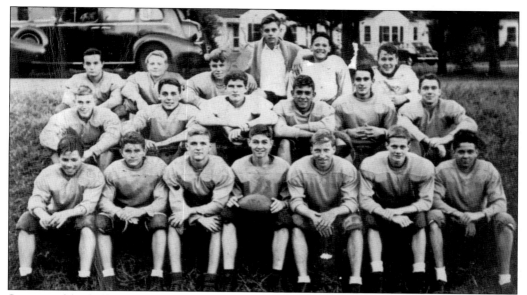

Sports, and football in particular, have always been popular, and the field on Heathermoor Road was the meeting place for football and fun on Sunday afternoons. Pictured is the 1946 Sigma football team. From left to right are (first row) Gordon Robinson, Vann Perkins, Arlen Carpenter, Bayard Tynes, Linton Selman, Billy Lanning, and John Morrow; (second row) unidentified, Fred Taylor, Paddy LaClaire, Johnnie Hall, unidentified, and Jimmy Bell; (third row) Gene Bromberg, Mayo Holloway, Jim Downey, Harold Graham, Blucher Cooper, and Ivey Jackson. (Courtesy of RFC.)

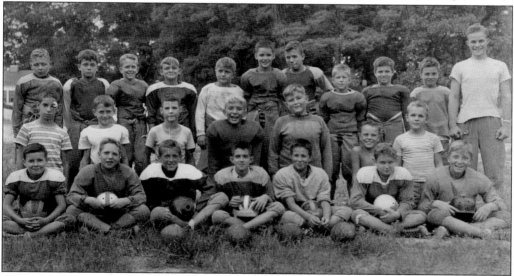

The 1948 Crestline Heights School eighth-grade football team included, from left to right, (first row) Jimmy Denton, Walter Morris, Charles Kidd, Wes Burnham, Bob King, Lynn Strickland, and Billy Brown; (second row) Joel Rotenstreich, A.B. Mainard, Jack Carl, Daniel Rather, Charles Thuss, Charles Heston, and Teddy Agee; (third row) Richard Gotlieb, Cullom Walker, Roy Evans, Andy Strickland, Jack Schultz, Hank Kirkby, Dicky Wise, Bordon Burr, James King, Clyde Taylor, and coach Billy Waterhouse. They played teams such as Edgewood, Shades Cahaba, Mountain Brook, Hall Kent, and New Merkel. (Courtesy of Walter Morris.)

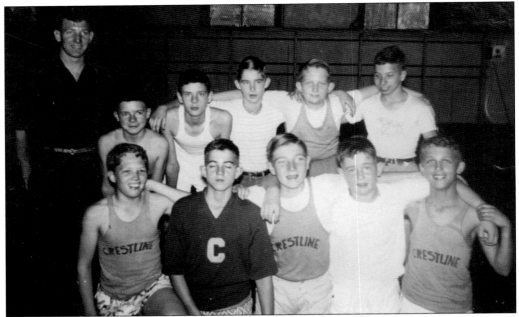

The 1949 Crestline basketball team played at the YMCA before the schools had their own teams. Pictured from left to right are (first row) Walter Morris, Wes Burnham, Billy Brown, Charles Thuss, and Charles Kidd; (second row) Coach Jessie Meeks, Jimmy Denton, Mandeval Smith, Ed Mundine, Vastine Stabler, and Dicky Wise. (Courtesy of Walter Morris.)

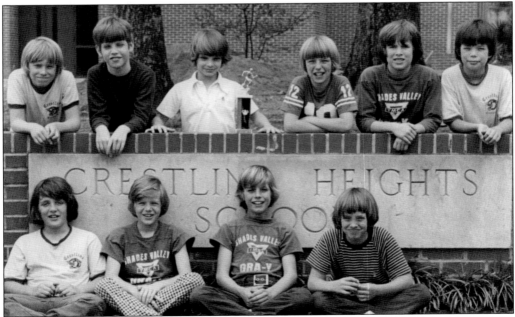

Crestline Elementary had its own track team, which placed first in 1974. Pictured in front of the school are, from left to right, (first row) David Sherrod, Davy Bennett, John Gardner, and Henry Morris; (second row) Frank Shoemaker, Barry Gunter, Gene Bromberg, Jamie Wagstaff, Lane Hunt, and Lyle Darnall. Coach Carter is not pictured. (Courtesy of Melanie Gardner.)

Coed soccer teams became popular in the mid-1980s. Here, coaches Cathy and Bob Geller pose with their team for a group photograph at their end-of-the-year party. The dog was the team mascot; he attended every game and even had his own team jersey. They played at the Crestline football field. (Courtesy of Claire Goodhew.)

Charlton Bargeron, Walter Morris, and Walter Morris Jr. coached the 1980 Mountain Brook Athletics baseball league in its very first year. Pictured here is the Crestline first-grade team. From left to right are (first row) David Bowsher, Jay Spencer, Hunt Abercrombie, Stephen Walker, Michael Terrell, Barry Berk, and Duncan Morris; (second row) Charles Crommelin, Lathrop Smith, Blake McKibbin, Colin McRae, and Josh Dawson. (Courtesy of Walter and Bee Morris.)

Hunting and fishing have long been favorite pastimes for many Mountain Brook men. Pictured from left to right are Leon Edwards, Bobby Parker, Richard Cox, Eddie Munger, Eddie Gentry, Gordon Robinson, and Joe Conzelman, who often hunted at Carlisle Jones's hunting camp and farm in Tishabee, located in Greene County. Alfred Shook was also a frequent hunter with this group. (Courtesy of Bobby Parker.)

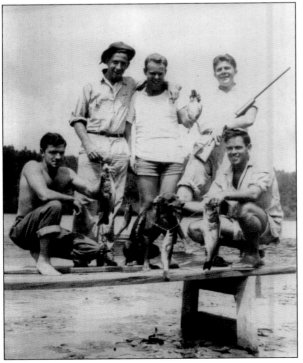

Pictured at Smyer Lake from left to right are fishing buddies Eddie Munger, Brandon Crawford, Arthur Fox, Andrew Scott, and Buddy Barcroft. Bill Strange took the picture. As a weekend and summer escape, multiple Mountain Brook families had second-home cabins on Smyer Lake. (Courtesy of Ann Hicks.)

The 25th reunion of the 1953 Theta Kappa Delta (ΘΚΔ) pledge class was held at Mountain Brook Club in 1978. Pictured from left to right are (first row) Cammie Boyd, Catherine Perry, and Lynne Simmons; (second row) Elsie Conzelman, Margie Davis, Barbara Shook, Louise Gillespy, Bee Morris, Din Collins, Orangie Chandler, Betty Jackson, and Zoe Cassimus; (third row) Bitsy Williams, Charlotte Murdock, Mary Matthews, unidentified, Lynn Wood, unidentified, Mary Gene Boulware, Forsyth Donald, Virginia Shepherd, Catherine Cabaniss, Mimi Tynes, Jody Ballenger, and Lucy Brantley. (Courtesy of GFC.)

In 1989, Alpha Delta Psi (ΑΔΨ) celebrated its 65th anniversary and held its third reunion at The Club. Pictured from left to right are (first row) Ann King, Martee McPherson, Sarah Creveling, Nancy Boone, Martha Yielding, and Mitzie Hodo; (second row) Marion Bradford, Mimi Norville, Ashley McGowin, unidentified, Dee King, and Ann McMillan, who served as chairman of the reunion. (Courtesy of Ann King.)

A tradition since the late 1990s, Sharp Gillespy has enjoyed planning Sigma reunions with interesting speakers for their luncheons three times a year. The 1947 Sigma pledge class is seen here in May 1999 at Birmingham Country Club. Celebrating age 70 are, from left to right, (seated) Devan Ard, Bland Wilson, and Paddy LeClaire; (standing) Sharp Gillespy IV, George Elliott, Ladd Goodson, Harold Graham, Linton Selman, Vann Perkins, and Eugene Norris. (Courtesy of GFC.)

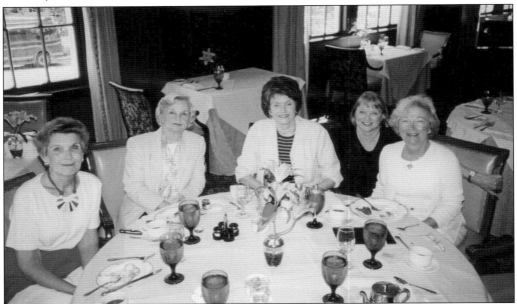

Pictured at the Botanical Gardens Restaurant are, from left to right, Eve Holloway, Harriett Murphree, Courteney Copeland, Louise Fletcher, and Kitty Robinson. Lifelong friends, they try to get together for a reunion every few years. Fletcher won an Academy Award for Best Supporting Actress in *One Flew over the Cuckoo's Nest* in 1975, which she starred in with Jack Nicholson. She portrayed Nurse Ratched, who has since become a cultural icon. (Courtesy of RFC.)

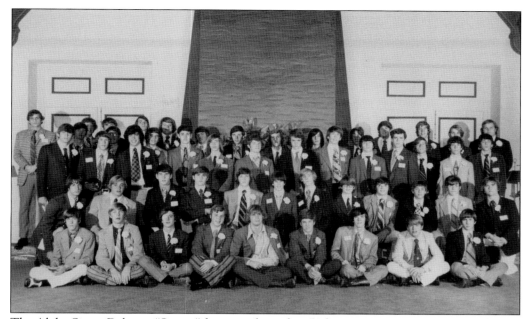

The Alpha Sigma Delta, or "Sigma," fraternity hosted its 50th anniversary reunion in March 1972 at Birmingham Country Club. "Little Sigma" had over 200 members attend the reunion, where they could reconnect, reminisce, and celebrate a long history of friendship. The local fraternities folded by the mid-1990s. (Courtesy of Fred Owen.)

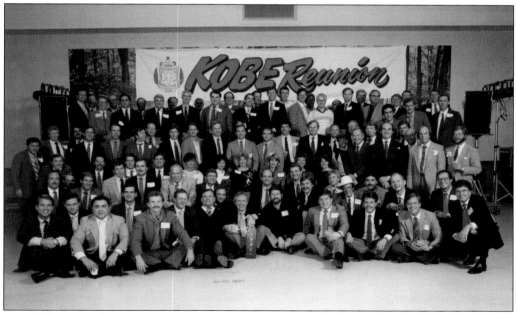

Founded in 1923, the Kappa Theta Phi fraternity was commonly called "Kobe," but the nickname was kept a secret. They held a reunion in the mid-1980s at the Botanical Gardens, bringing together many old friends. The fraternity published the Kobe Directory, which provided the names, addresses, and phone numbers for every fraternity and sorority member. Even when Kobe folded, its sister sorority, Alpha Delta Psi, still published the directory. (Courtesy of Ann King.)

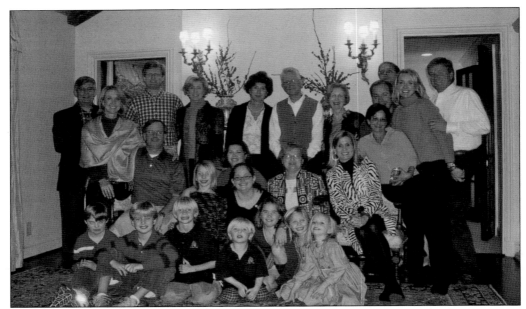

With the Christmas spirit never ending, Mtn. Park Circle has a reunion every year, where everyone who has ever lived on the circle is invited, including their children. The residents gather together for a reunion to celebrate their friendship and the bond of decorating the circle, a tradition since 1946. Pictured are members of the Gardner, Toomey, Bolvig, Ireland, Elliott, and Thomas families. (Courtesy of Melanie Gardner.)

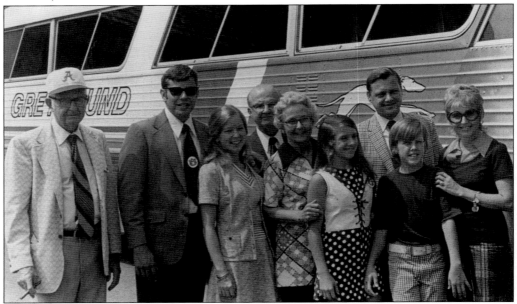

Longtime Auburn fans, the Gorrie family is pictured here loading the bus at Birmingham Country Club, headed for Legion field for the Iron Bowl in 1972. Auburn upset Alabama 17-16 that year. Pictured from left to right are Pete Greene; Johnny Greene and his wife, Milly; M.J. Gorrie; Mildred Greene; Ellen Gorrie and her father, Miller Gorrie; and Jim Gorrie and his mother, Frances. All three generations of the men pictured are Auburn graduates. (Courtesy of Ellen Walker.)

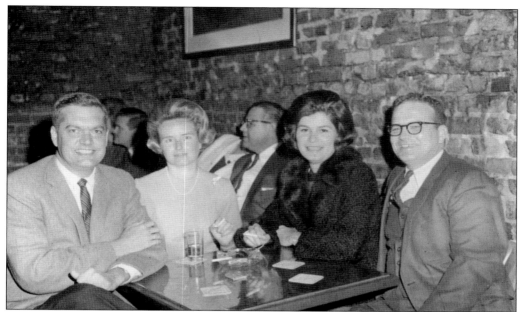

When football season rolls around each fall, Mountain Brook residents make a choice: they cheer for either the Alabama Crimson Tide or the Auburn Tigers. Mountain Brook is a very divided town over the rivalry. Pictured above are Buzzy and Jeanie Matthews (left) and Forsyth and Joe Donald (right), very close friends and huge Tide fans. They went to the Sugar Bowl in New Orleans in 1961 for the Alabama-Arkansas national championship game, which Alabama won with coach Paul "Bear" Bryant. Pictured below are the Faulkner children, (from left to right) Tricia, Genie, David, and Laurie, wearing their Crimson Tide activewear in their front yard in Cherokee Bend. (Above, courtesy of Forsyth Donald; below, courtesy of Laurie Hereford.)

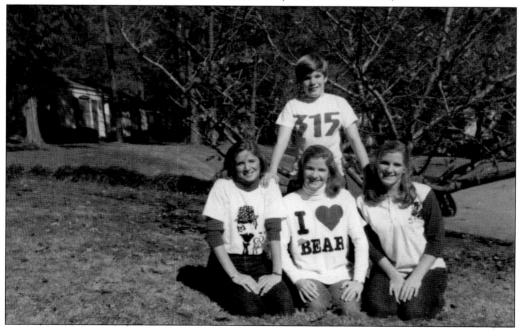

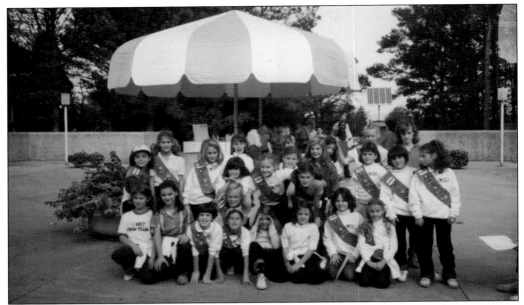

The Girl Scouts of America was formed on the premise that all girls should be given the opportunity to develop physically, mentally, and spiritually and to understand community service. Ida Mae Levio was committed to supporting the Girl Scouts, and she donated the Girl Scout Hut, where an average of 10 troops continue to meet. This troop is pictured at the Space and Rocket Center in Huntsville in the mid-1980s. (Courtesy of Claire Goodhew.)

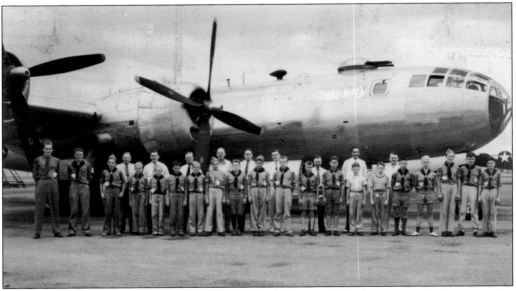

The Boy Scouts have played a large role in the Mountain Brook community in preparing young boys and instilling in them core values of responsibility, leadership, and integrity. Many community leaders have Boy Scout roots, such as Jimmy Rushton, George Elliott, Jimmy Shepherd, Jack Carl, and Richard Randolph. Pictured here in 1948 is Troop No. 53 at Hayes Aircraft to see the B-29 Modification Center, where warplanes were refurbished during World War II. (Courtesy of RFC.)

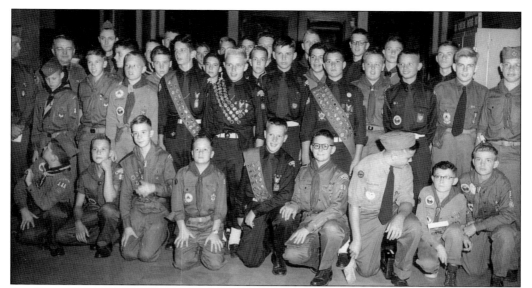

Boy Scout Troops No. 63 and No. 64 are pictured at the National Jamboree in 1953. From left to right are (first row) unidentified, Larry Clark, John Poynor, Chip Gamble, McGee Porter, Tommy Lane, Dan Allison, Lee VanBuren, and Olie McClung; (second row) unidentified, Jim King, Luke Bloodworth, Wilmer Poynor, Tommy Allen, Jack Martin, Wayne Vaughn, Johnny Schoppert, Jim Stephens, Gene Johnson, and Coffee Colvin; (third row) Troop 63 leader Winning Currie, Troop 64 leader Arnie VanBuren, Kim Neville, Morgan Howard, Charles Davis, George Atkins, Jack Carl, Charles Shook, unidentified, Paul McCain, Gerry Cabaniss, Bruddy Evans, and Sammy McCarley. (Courtesy of Jack Carl.)

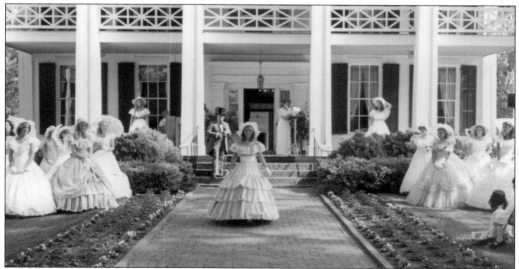

The Birmingham Belles, a service organization, gives senior high school girls the opportunity and experience of volunteerism and civic responsibility as they gain knowledge about their community. A long-standing tradition of over 45 years, the Belles wear beautiful antebellum-style gowns and are presented at the historic Arlington Antebellum Home, built in the 1840s, which is famous for its Greek Revival architecture. Frances Parker is pictured here in 1980 on the front lawn. (Courtesy of Melanie and Bobby Parker.)

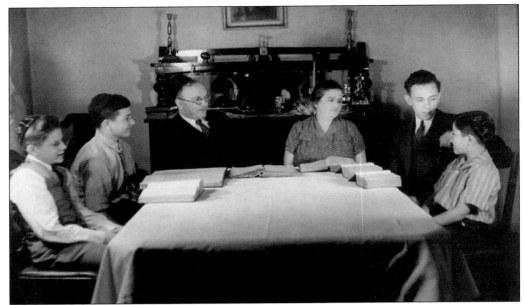

Passover is an important tradition that is more widely observed in the Jewish community than any other time, including Chanukah. The holiday is observed for seven or eight days, during which all leavened products are forbidden. Pictured at the dinner table discussing the Passover story of the Exodus from Egypt are, from left to right, Eph Mazer, Joseph Kimerling, Michael Kimerling, Chana Basa Kimerling, Joe Mazer, and Sol Kimerling. (Courtesy of Mary Kimerling.)

Pat and Claire Goodhew have hosted an annual Easter egg hunt since 1972, when they lived on Dexter Avenue. The tradition continued when they moved to Cross Ridge Road, where there is always a golden egg to be found. Pictured from left to right are Charlie Morgan, Pat Goodhew, and Bob Redus. Anyone who has ever attended the Goodhews' Easter egg hunt is always warmly invited again. (Courtesy of Claire Goodhew.)

Easter egg hunts have been a longtime tradition with Mountain Brook families. Here, Andy (left) and Sam Johnson pose for the camera after their egg hunt. Easter baskets were always teeming with dyed Easter eggs, stuffed and wind-up bunnies, books, crayons, candy, and, evidently, gobstoppers. Many children woke up to baby chicks as a surprise on Easter Sunday. (Courtesy of Sam Johnson.)

Traditionally, for every Christmas from the 1950s to the late 1990s, the McGriff family and their friends would go to Remlap, Alabama, to "the farm," to cut their shortleaf-pine Christmas trees. With the children all bundled up, the parents spread the picnic and built a fire, and they all roasted marshmallows and made s'mores. The parents enjoyed hot toddies to stay warm. Pictured here from left to right are unidentified, Joe Simpson, Lamar Ager, and unidentified. (Courtesy of MFC.)

The tradition of Mtn. Park Circle residents celebrating the Christmas spirit by creating a magical world of dancing lights and stars continues today. Pictured are Betty Jackson and her son Neal in 1969. On Montrose Circle in the late 1940s, Suzy Johnson and other mothers crafted nursery rhyme characters like Humpty Dumpty; Little Bo Peep; Mary, Mary, Quite Contrary; and Hickory Dickory Dock to celebrate the childlike wonder of the Christmas season. (Courtesy of Betty Jackson.)

As a Christmas tradition for years, the Canterbury Shop in Mountain Brook Village had a Santa Claus for the children to visit and share their Christmas list with. Santa would give them a memorable candy cane. These pictures have provided many happy memories through the years. Pictured are Tommy and Kathryn Wilson in the mid-1960s. (Courtesy of Mary K. Wilson.)

Halloween at the Gillespy house was always an event. Sharp Gillespy IV and a group of friends converted his parents' basement into a haunted house, making it a must-see for kids of all ages. It was called Gillespy's Ghost Gallery, and they charged a quarter for admission. One year, they netted $129.70, which they donated to the World Hunger fund through St. Luke's Episcopal Church. (Courtesy of GFC.)

Costumes were always such a big deal. Months before Halloween, children would beg their mothers to go to K-mart at Eastwood Mall to start shopping for their costumes. Pictured from left to right are Genie, an unidentified friend, and Laurie and Tricia Faulkner in Cherokee Bend, all ready to go trick-or-treating and fill their bags with candy. (Courtesy of Laurie Hereford.)

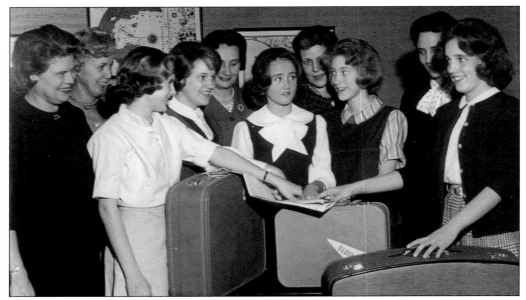

Mother-daughter trips have always been a tradition. These young ladies pose for a picture with their mothers before they embark on their first visit to the Big Apple in the summer of 1964, where they stayed in the Junior League rooms at the Waldorf-Astoria. Pictured from left to right are Jean Marks, Barrow Hiden, Margaret Marks, Katherine Hiden, Acky and Meg McGriff, Lydia and Yeardley Smith, and Murray and Muff Berry. (Courtesy of MFC.)

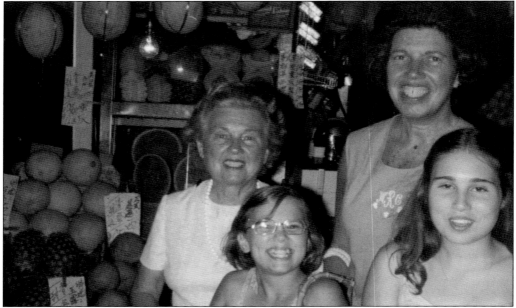

Mabel Robinson (back right), a Mountain Brook Junior High School physical education teacher for many years, is pictured with her mother, Mabel (back left), and her nieces (from left to right) Pattie Perry and Margaret Finney in Hong Kong as part of her continuing education. She earned her doctorate in health and physical education and later became the associate dean of the School of Education at UAB. (Courtesy of Pattie Perry Finney.)

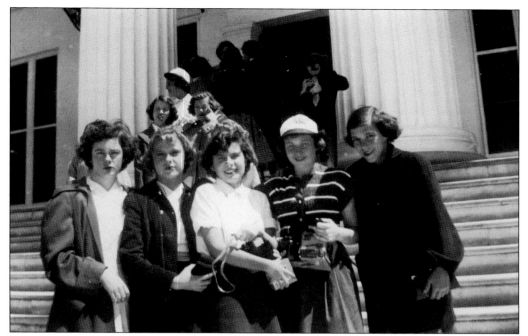

As a tradition for the eighth-grade senior trip at Mountain Brook Elementary, the students went to Montgomery to tour the state capitol. Pictured from left to right are close friends Peggy Stark, Orangie Wilkerson, Ann Westbrook, Bee Newman, and Margaret Cothran. This was an anticipated event for the recent graduates, with their cameras in hand. (Courtesy of Bee Morris.)

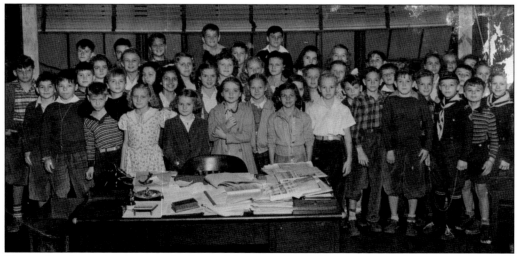

Pictured is the entire sixth-grade class at Mountain Brook Elementary on the annual class field trip, where they toured the *Birmingham News and Post Herald*. Some of the children pictured are, in no particular order, Gordon Robinson, Betty Hawkins, Dickie Mills, Hobart McWhorter, Varina Goodall, Frank Barker, Mary Jemison, Jimmy Rushton, Barry Evans, Jane Ann Mitchell, and Jack Trigg. (Courtesy of RFC.)

The Hassinger-Cabaniss family has had a family tradition that may predate the camera. For generations, babies who are descendants of Virginia Del Bondio and William Henry Hassinger are proudly placed in the punch bowl (a wedding gift in 1893) on their baptism day. Their youngest daughter was Lucile Clara Hassinger (Cabaniss Foster), mother to Lucile Del Bondio Cabaniss (Krueger), Virginia Jelks Cabaniss (Collins), and Elbridge Gerry Cabaniss Jr. The treasured family tradition was shared by Mrs. Foster with her daughters, her grandchildren, and her great-grandchildren. Pictured is Din Cabaniss Collins with her godson, Jay Krueger, in 1962. (Courtesy of KFC.)

Mountain Brook native Courteney Cox, an actress famous for her role as Monica on *Friends*, returns home frequently to visit family. She is pictured here with David Arquette, her mother, Courteney Copeland, and her daughter Coco at St. Stephens Episcopal Church at Coco's baptism. The Rev. Doug Carpenter officiated on the memorable day. Actress Jennifer Anniston, a close friend, also attended. (Courtesy of Courteney Copeland.)

The Mountain Brook High School homecoming parade has always been an exciting event for the entire community. This photograph was taken on the corner of Montevallo and Overhill Roads in October 1978. The parade used to begin at Shades Valley Presbyterian Church and always ends with a celebration in Crestline Village, with parents, teachers, and students strewn along the parade route. (Courtesy of Mary K. Wilson.)

As a Fourth of July tradition for many years, the Mountain Brook Fire Department invited the neighborhood children down to Crestline Village to ride the fire trucks all day long. The children looked forward to this summer event with great anticipation. There was lots of excitement, hats, and fun to be had. (Courtesy of Claire Goodhew.)

Birthday parties in Mountain Brook have always been very creative, most imaginative, and festive. Girls and boys alike would have themed birthday parties in their homes, backyards, or local destinations around Birmingham. Ben Jackson's fifth birthday party, in 1963 at the Eastwood Mall Kiddie Karnival, was a hit, with guests riding the roller coaster, bumper cars, and the super slide. Pictured from left to right are Ben Jackson, Jimmy Ard, Allen Corey, Chap Jackson, Carter Harsh, Sandy Wade, Arlen Carpenter, Art Durkee, Henry and Burr Weatherly, Belton Cooper, and Eve Jackson. (Courtesy of Ben Jackson.)

Built in 1951 atop Red Mountain, with its sweeping panoramic views of the city, The Club was the place to celebrate birthdays, holidays, and special occasions. Dinner with a Shirley Temple, dancing on the multicolored dance floor, and a photograph in front of the dove cage were musts. Pictured here in 1969 from left to right are Tricia, Genie, and Laurie Faulkner. (Courtesy of Laurie Hereford.)

Dress-up party! From left to right, Pam Tilly, Barbara Fleck, Patsy Davis, and Kathy Davis were a sight for sore eyes when they got into their mothers' closets to dress up for this birthday party. The girls were close friends growing up in Crestline and loved any excuse to dress up. (Courtesy of Peggy Montgomery.)

This Tom Thumb Wedding was held in 1948 at the Mountain Brook Methodist Church, which later became St. Luke's Episcopal Church and is now Steeple Arts. Julia Cole was the glowing bride, Tommy Lang was the groom, Helen Morris was the maid of honor, and Jim McPherson was the best man. Peggy Pate and Judy Parker were flower girls, and Jim Stephens was the preacher. The wedding was a production of the Women's Society of Christian Service. (Courtesy of Canterbury United Methodist Church.)

Cousin Cliff was a local magician and celebrity who had a television show. Many times, birthday parties were hosted at the station. Other times, he came to homes and did magic tricks and made blow-up balloon animals for all the children as party favors. Cousin Cliff is seen here with Bobby Gardner at his sixth birthday party in 1971. (Courtesy of Melanie Gardner.)

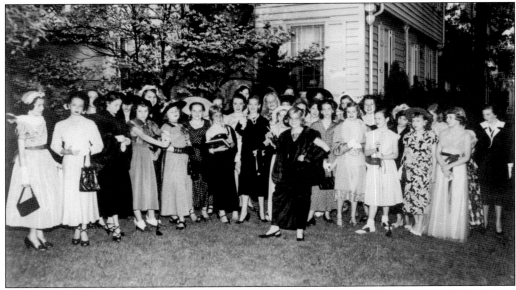

Virginia Fox was notorious for having fabulously themed birthday parties every year. At her home in Colonial Hills on Clarendon Road, "Dress up Like Your Mother" was quite a hit. Fox is in the center, and some of the others pictured are, in no particular order, Betty Timberlake, Kyle Badham, Mary Frances Lathrop, Christina Callahan, Margaret Brabston, Louise Parler, Celeta Barnes, Pattie Perry Robinson, Bonnie Shaw, Helen Morris, and Nancy Graves. (Courtesy of Betty Knight.)

Four

VISIONARY LEADERSHIP
A SERVANT HEART, GENEROSITY, AND QUALITY OF LIFE

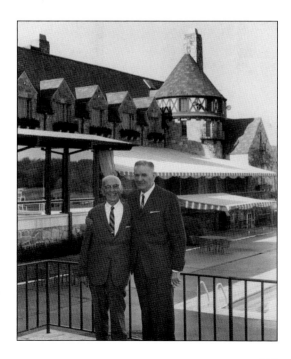

Named "Our Most Founding Father" in 1959, Robert Jemison was involved in many civic organizations throughout his life, including being the first president of the Birmingham Chamber of Commerce, the first chairman of the American Red Cross, and the chairman of Community Chest/United Fund. A devoted husband and father, he loved, worshipped, and led by example. His nephew Elbert Jemison Jr. said, "He focused on serving his fellow man, on helping make the world a better place for all to live. He personified confidence, inspiration, and leadership. He was always the perfect gentleman. He was caring, respectful and polite to everyone in all walks of life." (Courtesy of JFC.)

Drayton Nabers Jr. is a quiet and humble man with a true servant heart. He has influenced, inspired, and helped better the lives of many people who have crossed his path. Former chief justice of the Alabama Supreme Court and CEO of Protective Life Corporation, Nabers has served his community through the Kiwanis Club, United Way of Central Alabama, the Salvation Army, the UAB President's Council, and numerous other civic and corporate groups, including Cornerstone School. For the last decade, he has helped establish Christ-centered orphanages and schools in Rwanda. Currently, he serves as the director of the Mann Center for Ethics and Leadership at Samford University. (Courtesy of Drayton Nabers.)

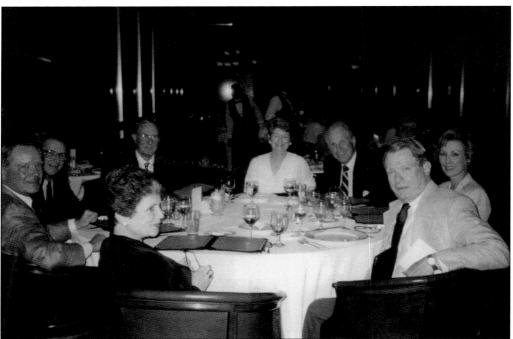

In 1993, with faithful community and business leaders, Drayton Nabers founded Cornerstone School, seeking to intervene in the endless cycle of poverty perpetuated by a lack of access to quality education in Birmingham's urban neighborhoods. The school has "quietly, intentionally and persistently" provided a Christ-centered education, developing the heads and hearts of thousands of Birmingham children. Pictured clockwise from front left are Melanie and Bobby Parker, Molton Williams, Jimmy Simpson, Hope Williams, Wayne Rogers, Mary Steiner, and Biddle Worthington at a 1999 benefit for Cornerstone School. (Courtesy of Bobby and Melanie Parker.)

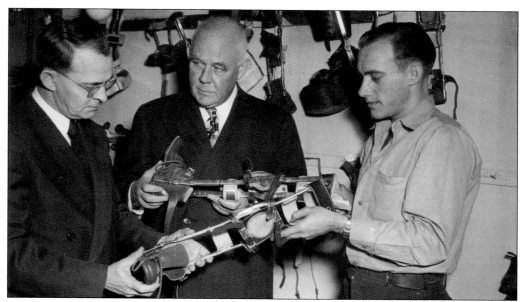

Through the efforts of *Birmingham News* sports editor Henry Hardin "Zipp" Newman (left), many annual sports events were established in Birmingham, earning hundreds of thousands of dollars to benefit the Crippled Children's Clinic. It was through his selfless concern, fine leadership, and spirit that he guided the Birmingham community to do outstanding work for the sick. Newman combined his love for sports with his strong conviction to help the sick to make a long-lasting difference in this community. (Courtesy of Bee Morris.)

For many years on Thanksgiving Day, the Birmingham community came together to support two all-star high school football teams that played for the championship at the annual Crippled Children's Clinic Football Game. Legion Field was furnished rent-free, and the Monday Morning Quarterback Club, the *Birmingham News-Age-Herald*, and WSGN made significant contributions. All proceeds were donated to the clinic. This remarkable support is a testament to the size of this community's heart for those in need. Pictured is the Ramsay Rams vs. Woodlawn Colonels program from 1947–1948. (Courtesy of RFC.)

Emily Symington Wilson was a pioneer in the Mountain Brook volunteerism community. Very active as a volunteer in the Birmingham area, she was a Red Cross volunteer during World War II. In the late 1940s, although a sustaining member of the Junior League of Birmingham, she worked tirelessly to persuade the league to start the Hearing and Speech Clinic and school for children. It eventually became part of Children's Hospital. In her retirement, Wilson summered in Linville, North Carolina, where she answered the phone for the volunteer fire department, just to help out. (Courtesy of TFC.)

Pictured with her husband, Bill, Mimi Wilson Tynes, the Junior League president in 1976, followed in the philanthropic footsteps of her mother, Emily Symington Wilson. Tynes's interest in community volunteerism was born as she learned about projects her mother was involved in through dinner table conversation, half-heard telephone conversations, and tagging along to meetings. An active member of the Junior League for 20 years, she had firsthand involvement with many nonprofit organizations; that experience fed directly into her work as the first program officer and executive director of the Greater Birmingham Foundation in 1998. (Courtesy of TFC.)

Serving as an air-raid warden during World War II, June Emory also volunteered as a Gray Lady with the American Red Cross throughout the war until her husband returned home. In 1962, she resumed her Red Cross affiliation as chairman of special volunteer services for the Jefferson County Chapter for 22 years. With a committed volunteer spirit, she also served as the women's chairman for Birmingham's annual Veterans' Day parade for 32 years. (Courtesy of June Emory.)

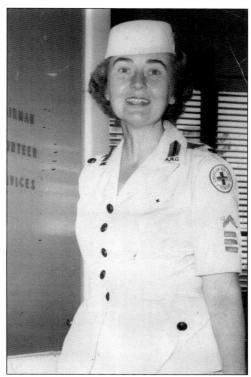

Committed to promoting volunteerism, developing the potential of women, and improving the community, many leaders of the Junior League of Birmingham have been from Mountain Brook. The League does arduous work in identifying real needs of the larger Birmingham community and establishing programs such as Pathways, the Literacy Council, and Oasis Women's Counseling. Pictured clockwise from bottom left are Alice McSpadden, Ellen Jackson, Murray Berry, Jane McDonald, Acky McGriff, and Bibby Smith at the Junior League Follies in the 1960s. (Courtesy of MFC.)

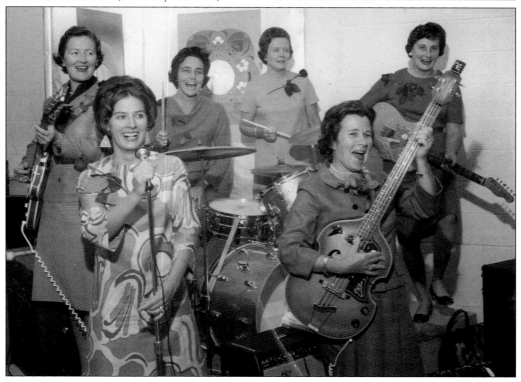

A prominent leader in Birmingham's civic and cultural affairs for over 50 years, Pattie O'Neil Rust, the wife of Henry B. Rust, opened and entertained in her home on East Briarcliff Road for many civic organizations, including the Alabama Symphony, the Birmingham Music Club, the Birmingham Festival of the Arts, the St. Andrews Society, and holiday tours in support of local churches. A past president of the Junior League of Birmingham, she was deeply involved in the welfare of the Mountain Brook and Birmingham communities. (Courtesy of GFC.)

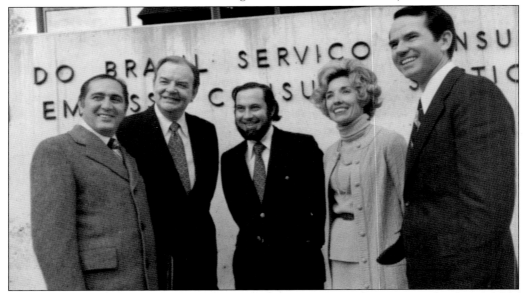

For more than 20 years, the Birmingham Museum of Art hosted the International Festival of Arts, a cultural, interactive festival that celebrated and featured a country, its people, culture, art, and cuisine for the Birmingham community to learn about and experience. The annual festivals provided exposure and insight into other cultures for adults and children alike. In 1975, the festival saluted the arts of Brazil. Pictured is chairman Kathleen Bruhn with Brazilian diplomats in Brazil, where she gave a speech in Portuguese. (Courtesy of Katie Patrick.)

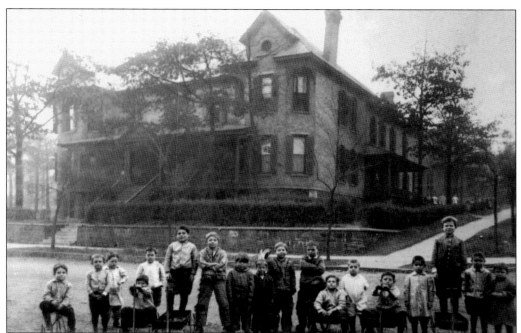

For Walker Jones, as a great-granddaughter of Robert Jennison Jr., philanthropy is a family legacy. Gateway, Birmingham's oldest social service agency (it began as Mercy Home in 1891), has been the focus of her heart for over 20 years. She has served on the board of directors and as an advocate, marketing advisor, top fundraiser, and chairman for five years. Gateway is dedicated to transforming the lives of families in crisis through foster care, counseling, education, and prevention programs designed to give them tools they need to survive, recover, and grow to the point they no longer need assistance. Pictured above is the first Mercy Home in 1903, and below is Gateway's current resident treatment program facility, near the airport, built in the 1920s. (Both courtesy of Gateway.)

Glenn Ireland is a man full of compassion who watched his parents struggle in finding the right medical care for his sister, who had special needs. Realizing the need to have a facility where families could find the services, counseling, education, and training they needed in the community, he founded Glenwood in 1974. Glenwood provides hope to families with children diagnosed with autism and behavioral issues. Through more than 20 services for children, adolescents, adults, and families with mental health needs, Glenwood maintains a professional staff and provides treatment with a continuum of care from early childhood to adulthood for individuals. It is a facility where autistic children and adults of all ages have access to learning, housing, and the like, which they would not otherwise be able to get. Glenn Ireland is seen here speaking at the dedication of the Allan Cott School in 1986 (left) and at the opening of the Quarterback Club Hall and Center (below). (Both courtesy of Glenn Ireland.)